PITTSYLVANIA COUNTY
VIRGINIA

A BRIEF HISTORY

Larry G. Aaron

Published by The History Press
Charleston, SC 29403
www.historypress.net

Copyright © 2009 by Larry G. Aaron
All rights reserved

First published 2009

Manufactured in the United States

ISBN 978.1.59629.531.5

Library of Congress Cataloging-in-Publication Data

Aaron, Larry G.
Pittsylvania County, Virginia : a brief history / Larry G. Aaron.
p. cm.
Includes bibliographical references.
ISBN 978-1-59629-531-5
1. Pittsylvania County (Va.)--History. I. Title.
F232.P7A226 2009
975.5'665--dc22
2009000428

Notice: The information in this book is true and complete to the best of our knowledge. It is offered without guarantee on the part of the author or The History Press. The author and The History Press disclaim all liability in connection with the use of this book.

All rights reserved. No part of this book may be reproduced or transmitted in any form whatsoever without prior written permission from the publisher except in the case of brief quotations embodied in critical articles and reviews.

*For my twin sisters
Bonnie and Connie*

Contents

Acknowledgements 7
Introduction 9

Chapter 1. People of the Land 13
Chapter 2. The First Pittsylvanians 16
Chapter 3. The Explorers 24
Chapter 4. Colonial Settlers 32
Chapter 5. A Gathering Storm 45
Chapter 6. The Road to Yorktown 53
Chapter 7. Antebellum Days 64
Chapter 8. Tobacco Rows and Roads 80
Chapter 9. The Other Pittsylvanians 87
Chapter 10. A Village on the Dan 99
Chapter 11. The Civil War 106
Chapter 12. Hard Times and Recovery 120
Chapter 13. The Twentieth Century 129
Chapter 14. Millennium Makeover 148

Bibliography 157

Acknowledgements

In writing this brief history of Pittsylvania County, I have stood on the shoulders of others past and present. Their work is vastly more complete and detailed than this small volume in which I have attempted to present an overview of the people, places and events that have figured significantly in Pittsylvania County history.

The research of Maud Clement elegantly presented in *The History of Pittsylvania County* and published in 1929 is one of the best county histories available anywhere. The extensive published research of local historians Frances Hallam Hurt; Herman Melton; Henry and Patricia Mitchell and their daughter Sarah; Judge Langhorne Jones; Lawrence McFall; Danny Rickets; Roger and Anna Dodson; and others have been generously woven into this narrative.

Helpful publications included *The Pittsylvania Packet*, published quarterly by the Pittsylvania County Historical Society; the county newspaper the *Star-Tribune*; the bulletin of the Virginia/North Carolina Piedmont Genealogical Society, *Piedmont Lineages*, edited by Mike Williams; the *Danville Register and Bee*; and the graduate work of Karl Bridges and Caleb Brumfield.

Additional assistance with contributions came from Carol Motley, Pittsylvania County's Economic Development director; William Gosnell, an authority on Pittsylvania County Native Americans; Deborah Morehead, director of communications and public relations for the Institute for Advanced Learning and Research; Terry Whitt, GIS coordinator for Pittsylvania County; Stephen Barts and Jamie Stowe, Pittsylvania County

Acknowledgements

extension agents; Susan Worley of the *Star-Tribune*; Gayle Beverley Austin with the VaGen Web Pittsylvania County, Virginia Genealogy Project; the Reverend R.G. Rowland, pastor of Greenfield Baptist Church; Peggy Hudson; Steve and Sarah Welch; Pam Rietsch of CFC Productions; Davis Newman, chairman of the Veterans Memorial Committee; Chris Anderson, manager of BB&T bank in Chatham; and Claudia Emerson, Virginia's poet laureate and Pulitzer Prize recipient.

Photographic contributions in addition to the author came from photographer Richard Davis, Pittsylvania County Archivist Desmond Kendrick, Lawrence McFall of Danville, Dr. William Black of Chatham Hall, the *Star-Tribune* archives, Mitchells Publications of Chatham, the City of Danville's Multimedia Design Manager Mark Aron, the Library of Congress archives and Nancy Compton for her cover art.

Help with research also came from librarians at both the Pittsylvania and Danville public libraries, and clerk of courts records in Chatham. Assistance in reviewing the manuscript came from Bonnie Dawson; Henry Walker; Stephen Barts; Leon Compton; Gary Grant; Henry Mitchell; Laurie Moran, president of the Danville Pittsylvania County Chamber of Commerce; Lawrence McFall; Deborah Morehead; R.G. Rowland; Mary Catherine Plaster; and Kenyon Scott, president of the Pittsylvania County Historical Society.

The staff at The History Press is due a heartfelt thanks, including Project Editor Ryan Finn and especially Senior Commissioning Editor Laura All, without whose patience and encouragement this work would not have been completed.

Finally, I wish to thank my wife, Nancy, for her devotion to me as I spent long hours in research and at the keyboard composing the manuscript.

INTRODUCTION

Out of Virginia's ninety-five counties, Pittsylvania County is the largest. Its geographical dimensions, including the independent city of Danville, amount to 1,027 square miles, making the county only 2 percent smaller than the state of Rhode Island. But there the similarities stop. According to the U.S. Census of 2000, Pittsylvania County's population was 61,783, while Rhode Island was heavily populated, with just over a million people. The population density in Pittsylvania is 65 people per square mile; by contrast Rhode Island has over 1,000 for each square mile.

Pittsylvania County is larger than the District of Columbia and seventeen of the world's smallest countries, including Vatican City, Monaco, San Marino, Liechtenstein and several independent island groups. It has a greater population density than Australia, Mongolia and Canada.

As a rural county, Pittsylvania is spacious and accommodating, with farms comprising 45 percent of its land area. Wide-open spaces still exist as they did during colonial days, and next-door neighbors are not necessarily right next door. It is a land of surprising beauty as well. Maud Clement, the county's premier historian, wrote that the early explorers saw "the great rolling hills which lost themselves in the blue distance, the murmuring waters of crystal clear streams, and the broad sweeps of rich meadowlands." It is still much like that today, a rural wonderland.

Pittsylvania County is situated along the South Central Piedmont Plateau, with elevations normally between 400 and 800 feet on rolling to hilly land. The Smith Mountain range crosses the northwest corner, where the county's

Introduction

highest elevation reaches 2,043 feet. The White Oak Mountain range crosses mid-county and continues northeast.

The Dan River meanders along its southern border; the Banister River divides the county into northern and southern segments. The Staunton (Roanoke) River forms the county's northern border. The county's other rivers are the Sandy River, Pigg River and Stinking River. The county has eighty-two named creeks plus branches, forks and unnamed streams. The total mileage of all these waterways is over 1,600 miles. Laid end to end, they would stretch from Virginia's Atlantic Coast to the middle of Colorado.

Pittsylvania County is surrounded by seven other counties: Bedford, Campbell, Halifax, Franklin and Henry in Virginia, and Caswell and Rockingham Counties in North Carolina. Danville, which began as a Pittsylvania County village of twenty-five acres, now comprises forty-four square miles. The community was part of the county for most of its existence, from 1783 until it received its charter as an independent city.

Pittsylvania has three incorporated towns—Hurt, Gretna and Chatham, the county seat. There are many smaller communities with names that have obvious local references, though some are not so obvious. Tightsqueeze, along today's Route 703 a short distance below Chatham, got its name from the difficulty wagons and buggies had in negotiating a narrow space between a blacksmith shop and a store, both built to the edge of the road. Renan got its name from someone's admiration of French philosopher Ernest Renan. Kentuck was named by a traveler headed for Kentucky who stopped in the area for the night and never left. Ringgold nearby supposedly offered good prospects for gold mining, but hardly enough was ever found to even make a ring.

The county history begins much earlier than its written documents imply. This landscape at the foot of the Appalachian Mountains was framed over eons of time in the distant past. Pittsylvania's wilderness was first tamed by Native American Indians and then by European immigrants—civilizations that tapped the forests, streams and land for their abundance.

The county was named after William Pitt, the Earl of Chatham, a British statesman supportive of the colonies during the American Revolution. Pittsylvania County servicemen fought in the Revolution, the Civil War and World War II—wars that won our independence, defined our nation and made the world safe for democracy.

From 1767 until 1777, when it became its present size, Pittsylvania included part of Franklin and all of Patrick and Henry Counties and extended to the Blue Ridge Mountains. From the beginning, tobacco has always been its

Introduction

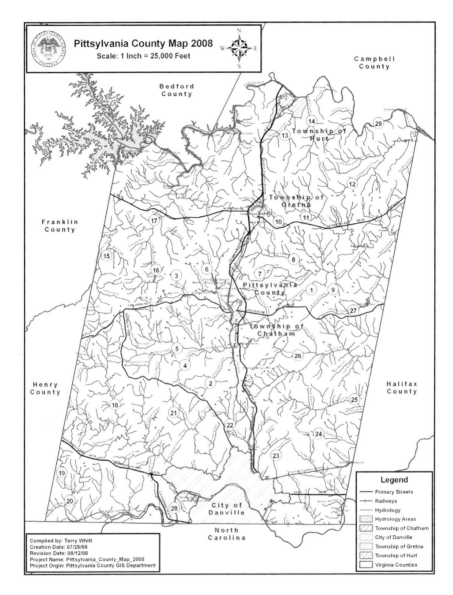

Pittsylvania County Map 2008 with major townships, roadways and rail lines, the city of Danville and county waterways with major streams named. *Prepared by Terry Whitt of Pittsylvania County GIS Department.*

1. Banister River; 2. White Oak Creek; 3. Bearskin Creek; 4. Pudding Creek; 5. Strawberry Creek; 6. Cherrystone Creek; 7. Mill Creek; 8. Whitethorn Creek; 9. Shockoe Creek; 10. Georges Creek; 11. Stinking River; 12. Straightstone Creek; 13. Sycamore Creek; 14. Reed Creek; 15. Turkey Cock Creek; 16. Tomahawk Creek; 17. Pigg River; 18. Sandy River; 19. Cascade Creek; 20. Pumpkin Creek; 21. Sandy Creek; 22. Fall Creek; 23. Cane Creek; 24. Double Creek; 25. Birch Creek; 26. Sweden Fork Creek; 27. Elkhorn Creek; 28. Dan River; and 29. Staunton (Roanoke) River.

INTRODUCTION

number one crop. In time, textiles mills sprang up along the Dan River, but now technology leads the way.

Pittsylvania County history has always been tied to the land, the waterways and its people. It is not over but continues to be made, a little each day. Here now is the rest of the story.

Chapter 1

People of the Land

Before human footprints ever graced the landscape of Pittsylvania County, a dynamic history had already been written beneath the ground. Billion-year-old volcanic rock exposed along the Dan River near Union Street Bridge in Danville serves as a snapshot of the monumental geologic forces that pushed, folded and faulted the region in ancient times.

The latitude and longitude of the geographic region destined to become Pittsylvania County was once ocean water, a grand stage for the dramatic shoving and shifting of rock layers in the continental collisions to come. About five hundred million years ago, as advanced life-forms began to develop on the planet, the continental crustal plates of North America and Africa collided and crumpled together like an accordion, forming the Appalachian Mountains. Rock layers shot upward and downward on a roller coaster ride as volcanic islands similar to those of Japan were crushed between them, their lavas seeping into the mix.

The supercontinent Pangaea, formed from these collisions, began breaking apart 250 million years ago. The rifting resulted in a Triassic lake basin that developed in the Pittsylvania County region around 225 million years ago. The Appalachians, which once were taller than the Rocky Mountains of the western United States, became weathered and eroded by nature's elements and gradually wore down. Sediments spilled into the basin and later formed into rock.

Since North America lay nearer the equator than it does today, the county experienced a much warmer climate with extraordinary flora and

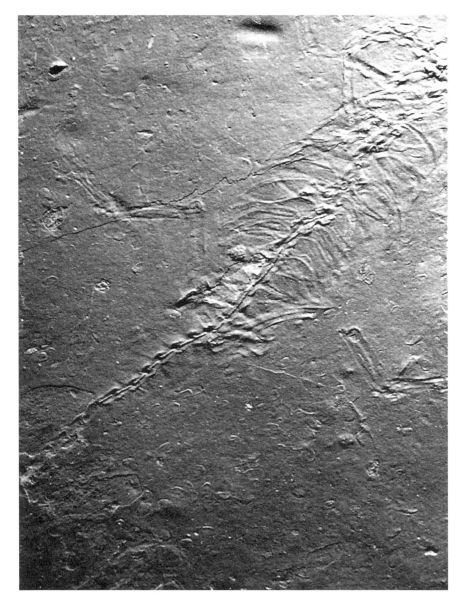

This Tanytrachelos fossil represents a new aquatic reptile found at the Solite Quarry in the Cascade community of Pittsylvania County.

fauna inhabiting this ancient lake environment. Evidence of that past life permeates local fossilized rock. Pittsylvania County contains the only known deposit of Triassic insects, a new aquatic reptile Tanytrachelos and is considered by many scientists as one of the top five fossil sites *in the world*.

People of the Land

Paleontologist Nicholas Fraser of the Virginia Natural History Museum in Martinsville, Virginia, commented on the fossil finds: "Back in the middle of nowhere, in the backwoods of Pittsylvania County, is one of the world's premier fossil sites."

The fossils were discovered in the Cascade shale deposits at the Solite Quarry in the southwestern end of the county. Sediments from the lake also fashioned into shale, exposed along the Banister River in the eastern part of the county. There local naturalist Bill Hathaway discovered the first pre-dinosaur footprint known in the area.

As the continents of North America and Africa continued to separate, the Atlantic Ocean began to form. The local climate changed as North America moved farther from the equator. Mountains continued to wear down in the millions of years that followed, and a thick red clay soil developed. Pittsylvania's gently rolling landscape took shape during that time, and hardwood forests, abundant wildlife and grasslands covered the area. The Dan, the Banister and the county's other rivers and countless creeks bisected the rounded foothills and shallow valleys. For millions of years, these streams have transported sediment from the mountains to the sea without pause, and the process continues today nonstop.

At some point, likely by the end of the last ice age twenty thousand years ago, the descendants of migratory tribes from other continents journeyed across the land. Eventually, some found the Pittsylvania County region to their liking. They stayed and a new history began.

And it was precisely because they stayed and others came that Pittsylvania County developed as it has over the last four hundred years of written history. Power, transportation and sustenance from the rivers and streams; the productivity of the soil, the mineral and ore treasures in the rocks; the wide-open spaces and availability of land; the abundant game and forest; the beauty and serenity of the Piedmont landscape in the foothills of the Blue Ridge—all of these figure prominently into the history of Pittsylvania County.

It is a history that begins with the land and, like the county's myriad streams, flows seamlessly onward into the future. The county's place in the shadow of the Appalachians has influenced the people who came, how they lived and what they did. Today, many of their descendants continue to live in the county, caught up in the flux of changing times yet still a people of the land.

Chapter 2

The First Pittsylvanians

In May 2007, Virginia celebrated its auspicious beginning—the 400th anniversary of the settling of Jamestown. That settlement survived after years of struggle, but it meant the beginning of the end for the Native American tribes in Virginia who had lived on the land for thousands of years. They were the first Americans and their ancestors were the first humans to set foot in Pittsylvania County.

Native Americans discovered the Pittsylvania County landscape long before England, Spain or France existed as nations. They first heard the roaring rapids and the subtle murmurs of the Dan River and the Banister River that cross the county. Before any European settlements dotted the river valleys, Native Americans camped along those streams, developing their own highly cultured societies, evolving in technology and art and cultural institutions.

The Indian ancestors of those who lived in and around Pittsylvania County go back fifteen thousand years. As their population grew, they experienced environmental changes and social challenges yet continued to reinvent themselves, especially engineering technology that allowed them to adapt and prosper. For example, Keith Egloff and Deborah Woodward in *First People: The Early Indians of Virginia* write, "From 15,000 BC to AD 1600 the Indians of Virginia underwent a transformation from nomadic hunters to settled village farmers, from equal partners in small bands to members of elaborately organized chiefdoms."

The Indians had no modern-day conveniences, so it was man pitted against nature in a raw battle for survival. Having to develop their own

The First Pittsylvanians

tools and devise their own strategies to maintain their society was no small accomplishment, for despite its abundance, the natural world can be harsh and unrelenting as an obstacle to continued existence.

Before the ancient Egyptian, Greek and Roman civilizations appeared on the landscape, the ancestors of Virginia Indians likely crossed over from Asia on a land bridge that connected to North America, which is now under the Bering Sea off Alaska's coast. They made their way eastward and must have seen Pittsylvania County with an entirely different climate than it has today.

Virginia had no glaciers then, though they covered parts of Ohio and some of Pennsylvania. Still, the northern glaciers had a chilling effect on the climate south of the Appalachians. Cool temperatures prevailed, encouraging fir and spruce forests with grasslands that supported the grazing of larger mammals such as wooly mammoths, large bison and mastodons. Such plants did not yield food products suitable for humans, so these Paleo-Indians were nomadic, existing in temporary camps along streams, following the big game wherever they went. They roamed in small bands, traveled widely and interacted with one another.

They lived in the Stone Age, and their tool technology, though primitive, was efficient in bringing down large game and others such as deer, elk and bear. Referred to as Clovis tools, they were necessary not only to kill their prey, but also to skin the animal, scrape the hide, cut up the meat and split the bones of the animals. Fluted Clovis points dating back ten to twelve thousand years have been found in various sites around Pittsylvania County, proving that Paleo-Indians indeed must have been here for thousands of years.

At that time, water was tied up in glaciers, so Virginia's shoreline was farther east. About eight thousand years ago, a warmer climate, along with overhunting, depleted the big game. As the ice age ended, water levels rose in the Chesapeake Bay and in river valleys bordering the coast. The spruce and fir forests gave way to forests of oak, hickory, chestnut and pine trees. Nut-bearing trees along with fruits, berries and edible plants proliferated due to longer growing seasons and warmer temperatures.

Because food was more plentiful, populations increased and these Archaic Indians ranged over a more limited area. An article from *Virginia Places* titled "From Paleo-Indian to Woodland Cultures: Virginia's Early Native Americans" summarizes their status: "In other words, they settled down. They got to know a particular valley that provided water, fruit and nuts, plus fish and game. They knew where to hunt and when to harvest food from plants because they knew their territory."

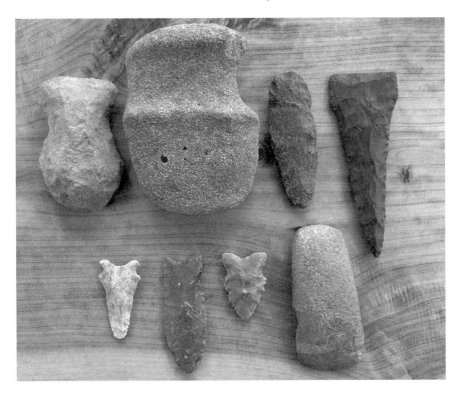

Native American artifacts from Pittsylvania County belonging to William Gosnell. *Top, left to right*: Archaic stone axe, Woodland grooved axe, Paleo-Indian blank point and Archaic point. *Bottom, left to right*: Archaic, Paleo-Indian and Archaic points, and a Woodland celt. Paleo-Indian dates from 15000 to 8000 BC, Archaic from 8000 to 1200 BC and Woodland from 1200 BC to European contact in AD 1600s.

They became a hunter-gatherer society. Because smaller game was more abundant, they reshaped their tools, notching their points in a way that was suitable to the game in that region. They also added tools reflecting the change in lifestyle. From its website, a Virginia Historical Society article ("Becoming a Homeplace"; www.vahistorical.org/storyofvirginia.htm) notes: "Over time, they developed new technologies. The spear thrower [called an atlatl] added range and power to the hunter's arm. The axe enabled people to fell trees. The mortar and pestle made it easy to pound and grind nuts, seeds, and roots." In Pittsylvania County, Archaic points from 8000–6000 BC, possibly used with an atlatl, and stone axes dated around 4000 BC, have been found at Native American sites.

The Archaic Indian period lasted from 8000 BC to about 1200 BC. During those several thousand years, their society evolved into larger bands

that settled along the floodplain of rivers, groups eventually merging to form small villages. *First People* offers this insight about their daily lives: "Findings suggest the Indians probably spent their days preparing food, knapping stone tools, smoke curing animal hides, sewing leather into clothes and bags, and repairing tools and weapons."

About 2,500 to 3,000 years ago, tribal identities emerged as the Indians became more sedentary and more technologically advanced. These Woodland Indians innovated fired-clay pottery, which they used for storing food and cooking. They made a great technological advance by redesigning the grooved axe to make a celt, which was smoother and polished, enabling them to work more accurately with wood than the coarse work done with the axe. They also exchanged their spears for the bow and arrow and redesigned the points into a more triangular shape for adaptation to a wooden shaft.

The Late Woodland culture from about AD 900 to AD 1600

> *achieved a richness of culture that was unmatched to date. They created a wide range of pottery forms and ceremonial and symbolic objects of stone, copper, and shell. Symbolic designs reflected an extensive mythology and belief system that included natural and supernatural figures. Sophisticated burial customs reflected the people's view of the world as a timeless cycle, as a continuous, unchanging succession of death and rebirth.*

They added to their hunting and gathering the cultivation of beans, corns and squash, thus requiring these early Americans to maintain permanent or semipermanent settlements. Forest Altman in *Adventures in the Dan River Basin* comments on the lifestyle of the Dan River people: "In the rich alluvial soil they raised many varieties of corn, peas, beans, pumpkins, watermelons, muskmelons, and potatoes; hunted birds for their meat and their parts for bone tools and personal adornment; utilized plants like gourds for food and kitchenware and hunted a variety of animals."

A sense of community developed in the Woodland culture as they collected into ever larger settlements, farming together and later joining into political, social and economic units best described as chiefdoms. These Woodland Indians traded extensively from tribe to tribe, exchanging their wares and crafts. Indian paths crisscrossed Pittsylvania County as faraway tribes made their way to and through the area.

In Virginia at the time of European contact in the 1600s, three language groups existed. The Algonquian-speaking people lived on the coastal plain and included the Powhatan confederacy; the Iroquoian-speaking people

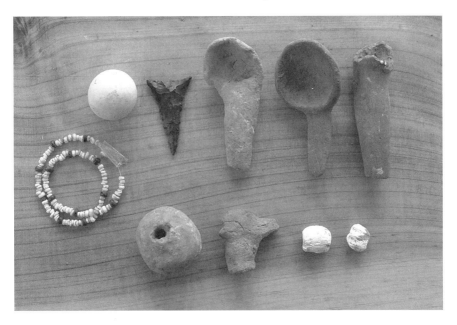

Native American artifacts from the Woodland period in Pittsylvania County belonging to William Gosnell. *Top, left to right*: game ball, Triangle point, two clay spoons and pipe stem. *Bottom, left to right*: clay bead, bird head effigy and two shell beads. Glass bead necklace dates to AD 1620–30.

such as the Nottoway and Meherrin lived south of the James River and the Cherokees in southwestern Virginia; the Sioux or Siouan-speaking people of the Piedmont included the Monacan and Manahoacs, who were descendants of the Late Woodland Indians, as were the Nahyssan, Occaneechi, Tutelo and the Saponi, residents of Pittsylvania County lands.

The Indians who made Pittsylvania their home were far from savages. They possessed a linguistically complex and rich culture and enjoyed a sense of family and community and skill levels that made them anything but ignorant. One of the first explorers to document Indian life was Dr. John Lederer in 1670. In his travels in Virginia, Lederer visited Saponi tribes in Pittsylvania's northern sector and recognized that the Indians were intelligent despite their lack of a written language. He explained:

> *Let us not therefore conclude them wholly destitute of learning and sciences: for by these little helps which they have found, many of them advance their natural understandings to great knowledge in physick, rhetorick, and policie of government: for I have been present at several of their consultations and*

The First Pittsylvanians

debates, and to my admiration have heard some of their seniors deliver themselves with as much judgment and eloquence as I should have expected from men of civil education and literature.

Lederer remarked further that "they worship one God, Creator of all things" and observed religious rites. They also believed that Mother Earth was the source of abundance and free to all. They believed that all things had life and spirit. For that reason, they were respectful of Earth's resources, only taking from the land what they needed and not abusing the rest. It never occurred to them that land should be claimed and boundary lines marked off.

Explorer William Byrd, who later came in contact with these Saponi tribes as he surveyed the Virginia/North Carolina boundary, described them in his *History of the Dividing Line* as "the bravest and honestest Indians Virginia ever knew" and as "great and venerable in their countenances, beyond the common mien of savages."

Byrd's Saponi Indian guide named Bearskin related details about their beliefs, which Byrd elaborated on in his diary. Saponi religious beliefs contained "the three Great articles of Natural Religion: the Belief in God; the Moral Distinction betwixt Good and Evil; and the Expectation of Rewards and Punishments in another World." According to William Gosnell, Bearksin's village was likely between Pumpkin and Cascade Creeks somewhere along the Dan River.

Despite the sophisticated culture and the technological advances of these descendants of Late Woodland Indians, their life is left to the archaeologist's shovel and the written records of explorers and settlers.

The demise of the Indian population of Virginia, taken as a whole, was not a result of its cultural deficiencies or tribal battles. Turf wars among Virginia's Native Americans appear no more unusual than the centuries of wars among European countries. But when the Europeans actually landed on Virginia shores, everything changed for the Indians. Michael Barber and David Hubbard Jr., in an article for *Journal of Cave and Karst Studies*, remark that Europeans "severely altered social trajectories, territories, material goods, health, and demographies" of the Indians. No initial overt effort materialized to rid the land of these first inhabitants; it came as a natural consequence of others also recognizing Virginia as a Promised Land.

In 1608, when Captain John Smith first ventured beyond the James River after establishing Jamestown, he became aware of Monocan Indian towns west of the James River falls at Richmond. Later, he captured an Indian

named Amoroleck, who told him that the Indians of the Piedmont avoided the English because they were "a people come from under the world to take our world from us."

Unfortunately for Pittsylvania County's Native American culture, Amoroleck's prediction proved correct, yet Pittsylvania remains a reservoir of the Indians' presence, with remnants of their lives evident in the fields and along streams in every section of the county. Survey records mention Indian forts and abandoned Indian fields. Fish weirs, V-shaped rock dams designed to funnel fish into an opening at the point, are found along both Pigg and Banister Rivers. Artifacts such as projectile points and pottery have been found abundantly in plowed fields throughout the county. Stream-side campsites have been located.

William Gosnell, a Pittsylvania County resident of Native American descent and an authority on the county's Indian culture, along with archaeologist Howard MacCord, coauthored an article published by the Archeological Society of Virginia describing a Dan River culture site northwest of Danville in the valley of Sandy River. That site and another

The remains of this V-shaped stone dam or fish weir, built by Native Americans centuries ago, rests in the bend of the Banister River near the Markham community.

The First Pittsylvanians

along Pumpkin Creek revealed a cache of artifacts—deer bone awls for piercing leather, clay spoons, bird head effigies of clay, pottery impressed with designs created by corncobs and netting, clay and shell beads, celts and clay pipes. Glass beads dated to 1620–30 were found at the site, indicating that European contact with area Indians may have been much earlier than previously thought.

Gosnell believes that evidence from these excavations along Sandy River and Pumpkin Creek shows that Native American buildings in Pittsylvania County were typical of these Woodland settlements. The American Indians lived in arborlike oval houses with sapling poles bent and tied together and probably covered with bark, mats or animal skins.

A research report by the Virginia Department of Human Resources depicts three sites within Pittsylvania County at Leesville Lake that revealed abundant ancient artifacts spanning the time from the Paleo-Indian to the Late Woodland occupations of Native Americans. Rock projectile points, hand drills, scrapers, knives and a host of other physical evidence found at these sites suggest that Pittsylvania County's Native American heritage represents a rich culture many thousands of years old. Theirs was a civilization much to be admired.

Chapter 3

The Explorers

The American Indians first explored Pittsylvania County, having crisscrossed the region thousands of years before Columbus "discovered" America. Their highly structured society and sophisticated culture developed long before explorers from Spain, France and England arrived. The Europeans were latecomers at best.

Nevertheless, the rolling landscape, clear mountain streams and blue mist rising in the west must have amazed those Virginia explorers and traders who first traversed Pittsylvania lands. What they saw was entirely different from the Tidewater, where Virginia settlers had spread out following the founding of Jamestown.

In *Virginia: A Bicentennial History*, Louis Ruben indicates that exploration of Virginia's lands was to profit from precious metals and minerals, establish a market for English goods, develop agriculture and carry the Gospel to heathen shores to save the "resident savages." These reasons played out in the exploration of Pittsylvania lands and are evidenced in the writings of the explorers.

A petition to the Virginia General Assembly in June 1641 by Walter Austin, Rice Hoe, Joseph Johnson and Walter Chiles requested "leave and encouragement to undertake the discovery of a new river of unknown lands bearing west southerly from Appomattox River" to enjoy the benefits of trade. "West southerly" would lead to Pittsylvania County.

In 1653, the General Assembly allowed Major Abram Wood, trader and explorer, and Edward Bland, merchant, "to discover and enjoy such benefits

The Explorers

White Oak Mountain's 1,148-foot elevation is prominent among the sixteen peaks and summits in Pittsylvania County.

and trade for fourteen years as they shall find out in places where no English ever have bin and discovered, nor have had particular trade." As they explored southwesterly from Fort Henry on the Appomattox, they learned from the Indians about the Staunton River, which determines the northern boundary of Pittsylvania County. They also learned of Occaneechi Island (then uninhabited Charles Island) at the confluence of the Staunton and the Dan Rivers.

Clarence Alvord and Lee Bidgood, in *The First Explorations of the Trans-Allegheny Region*, describe the Piedmont region that Wood and Bland explored as "hilly country sloping gently to the east."

> At the time when the explorers entered this practically unknown land, it offered a pleasant variety of forest and grass lands, intersected by narrow meadow and swamp tracts in the stream "bottoms." Here, as almost everywhere, the Indians followed the custom of burning over the country in the fall, so that the level uplands and long gentle slopes were kept as open grazing country, pasture for deer, elk, and buffalo...The

poorer, stonier, and steeper ground was covered with forest of deciduous growth, and the bottoms, where not cleared by the Indians for their fields, were covered with a practically impenetrable tangle of well nigh tropical luxuriance. Food for the wild things was plentiful, so that game was found in almost inconceivable abundance, and the abundant watercourses teemed with fish.

Edward Bland referred to this land as "New Brittaine" and remarked that it abounded with great rivers, had a more temperate climate than England and was a place easy to settle in.

In 1670, German physician John Lederer and an Indian guide explored Virginia's western lands, a journey recorded in Lederer's diary and published by Sir William Talbot in *The Discoveries of John Lederer*. In Lederer's writings, there is every evidence that one of early Virginia's most notable explorers passed through Pittsylvania County.

In describing the lands beyond the fall of the rivers, Lederer says, "The ground is over-grown with underwood in many places, and that so perplext and interwoven with vines, that who travels here, must sometimes cut through his way. These thickets harbour all sorts of beasts of prey, as wolves, panthers, leopards, lions, etc…and small vermine as wilde cats, foxes, raccoons."

Lederer mentions such Indian tribes as Nahyssan, Sapon, Akenatzy and Monakin, all tribes that likely would have been residents of Pittsylvania County at one time or another. He states further, "The parts inhabited here are pleasant and fruitful, because cleared of wood, and laid open to the sun. The valleys feed numerous herds of deer and elks larger than oxen: these valleys they call Savanae, being marish grounds at the foot of the Apalataei."

From June 5 to 9, 1670, Lederer and his "Sasquesahanough-Indian" guide named Jackzetavon traveled southwest from the James River to a village he called Sapon on a branch of the Staunton River, which is located on the border of present-day Pittsylvania, where it joins Campbell County. Lederer wrote that he found the Saponis "scituate upon a branch of the Shawan, alias Rorenock-River." He also mentions another Saponi town, Pintahae, a few miles from Sapon.

He next visited the Akenatzy, "an island bearing south by west, and about fifty miles distant, upon a branch of the same river, from Sapon." Lederer said, "This island, though small, maintains many inhabitants, who are fixed here in great security, being naturally fortified with fastnesses of mountains, and water on every side."

The Explorers

Lyman Carter, in an article for the *William and Mary Quarterly* titled "The Veracity of John Lederer," wrote, "The Akenatzy Island is at a horseshoe bend in the river after the river had broken through a short chain of lower mountains. The site suggested is not strictly an island but rather a peninsula abutting the Smith Mountains."

Local Native American descendant William Gosnell thinks that Lederer's travels southwest for three days from Saponi town to the Akenatzy "island" were hardly fifty miles. Gosnell believes that Lederer, instead of traveling through the gap at Smith Mountain (where the Smith Mountain Dam is today), crossed Pigg River in Pittsylvania County and traveled on an old Indian trading path that continued on to the mountains.

Lederer's route may have passed through the county on what is roughly Route 40 today, which cuts across the northern part of the county through Gretna and connects with Route 220, formerly the Iroquois Trading Path, at Rocky Mount. Lederer then turned south into North Carolina, passing through what became Pittsylvania County territory when its western boundary bordered the Blue Ridge. However, agreement by modern scholars concerning Lederer's route is not unanimous. Dr. Alan Briceland of Virginia Commonwealth University postulates that Lederer may have taken a more easterly path into North Carolina.

Those mountains were the goal of other explorers. Governor Berkley himself intended to head a party to search for the East India Sea beyond the mountains and along the journey hoped to find some mines of silver. Thomas Ludwell, Governor Berkley's secretary, wrote a letter mentioning the expected great sea or river that is bounded by the mountains and the confidence that "the bowels of those barren hills are not without silver and gold." The Akenatzy related to Lederer about their voyage over a great sea to the mountains, and Lederer concluded that the "Indian ocean does stretch an arm or bay from California into the continent as far as the Apalataean mountains."

In September 1671, Thomas Batts, Thomas Woods and Robert Fallam explored a similar route as had Lederer "for the finding out the ebbing and flowing of the Waters on the other side of the Mountaines in order to the discovery of the South Sea." Their search would have taken them through Pittsylvania County, but like the other explorers, they would be frustrated that a shorter route to the Orient with its spices and riches did not materialize, nor did they find valuables like gold and silver along the way.

However, even Lederer himself in his comments on Saponi town on the branch of the Staunton observed: "It enjoys the benefit of a stately river, and

a rich soyl, capable of producing many commodities, which may hereafter render the trade of it considerable." Lederer also suggests that if skins of deer, otter, beaver, wildcat, fox, raccoon, etc., are desired from Indians, then trade should be for cloth, axes, hoes, knives, scissors and "all sorts of edg'd tools," beads and bracelets of glass and "all manner of gaudy toys and knacks for children."

The explorers, whatever their motives, provide us with exalted description of the Piedmont. Robert Beverley's *The History and Present State of Virginia*, published in 1705, exults in the "Mixture of Hills, Vallies and Plains" and that the land is a cornucopia "full of Streams and pleasant Springs of clear water." Beverley wrote:

> *In some Places lie great Plats of low and very rich ground, well Timber'd; in others, large Spots of Meadows and Savanna's, wherein are Hundreds of Acres without any Tree at all; but yield Reeds and Grass of incredible Height. And in the Swamps and sunken Grounds grow Trees, as vastly big, as I believe the World affords, and stand so close together, that the Branches or Boughs of many of them, lock into one another.*

Beverley describes "the rich Lands that lie next to the Rivers and Branches, stored with large Oaks, Walnuts, Hickories, Ash, Beech, Poplar, and many other Sorts of Timber" and that "the Rivers and Creeks do in many Places form very fine large Marshes, which are a convenient Support for their Flocks and Herds." He also mentions "Mineral Earths" and "'tis' believe'd, they have great Plenty and Variety." Iron, lead and minerals might be mined, he thought, but also points out the varieties of rich soil suitable not only for growing crops but also for making clay vessels.

Colonel William Byrd II, whose party surveyed the dividing line between Virginia and North Carolina, published the first close-up account of Pittsylvania land. In an article on "Pittsylvania County's Southern Border," Henry Mitchell pinpoints Byrd's exploration of the region and the campsites of his surveying party. Accurate locations of some of his campsites can still be seen today.

Byrd himself wrote two compilations of his travels, published in 1841 as *The Westover Manuscripts*, containing *The History of the Dividing Line* and *A Journey to the Land of Eden*, which give his comments and observations. Byrd first crossed the "South Branch of the Roanoak River" on October 10, 1728, and named it after the Dan River mentioned in the biblical Garden of Eden:

The Explorers

The Dan River, just upstream from the Schoolfield Dam as it flows eastward toward Danville's business district.

> *The Bottom was cover'd with a coarse Gravel, Spangled very thick with a Shining Substance, that almost dazzled the eye, and the Sand upon either Shore Sparkled with the same Splendid Particles. At first site the Sun-Beams giving a Yellow cast to the Spangles made us fancy them to be Gold-Dust, and consequently that all our Fortunes were made...But we soon found our Selves mistaken, and our Gold-Dust dwindled into small Flakes of ising-glass. However, tho' this did not make the River so rich as we cou'd wish, yet it made it exceedingly Beautiful.*

This crossing was at the Milton Bridge on Virginia/North Carolina Route 62, just barely south of Pittsylvania County's right corner. The Byrd party camped that evening on Cane Creek, which flows along the eastern side of Danville through the Kentuck and Ringgold section of Pittsylvania County and into the Dan River less than a mile away after it enters North Carolina. Byrd wrote, "We crost a Creek 2 Miles beyond the River, call'd Cane Creek, from very tall Canes, which lin'd its Banks. On the West Side of it we took up our Quarters."

The next night, October 11, they crossed the Dan a second time and commented on the abundance of cane or native bamboo that lined the banks.

Though not as wide as when his party crossed the preceding day, Byrd said of the Dan River, "It was still a beautiful stream, rolling down its limpid and murmuring waters among the rocks." From a ridge nearby the surveying party caught a glimpse of the Blue Ridge. "They seemed to lie off at a vast distance, and looked like ranges of blue clouds rising one above another." That night they camped near the location of Danville's Goodyear Plant just south of VA 737. Byrd wrote, "We encamp about two Miles beyond the River, where we made good chear upon a very fat Buck, that luckily fell in our way. The Indian [Bearskin] likewise Shot a Wild Turkey."

By October 16, Byrd wrote, "The high land we traveled over was very good, and the low grounds promised the greatest fertility of any I had ever seen." The party was about to cross the river for the fifth time but had to ride south along the river to find a ford. Along the way "we traverst Several Small Indian Fields, where we conjectur'd the sawroes [Sauras or Cheraws] had been used to plant Corn, the Town where they had liv'd lying Seven or Eight Miles more Southerly, upon the Eastern Side of the River." These cornfields were on VA 880 in Pittsylvania County at the State Line Bridge.

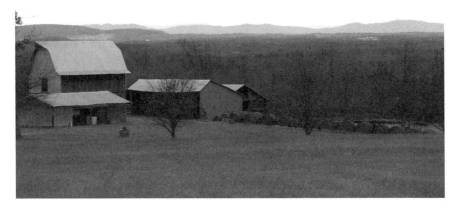

A view of the Smith Mountains and the Blue Ridge Mountains beyond them in the background of a Pittsylvania County farm in the Worlds community.

The Explorers

On October 17, they crossed the Dan for the last time on their 1728 survey. Byrd wrote that the Dan took a southerly turn near a "very flush and plentiful stream," which today we call Pumpkin Creek, located in the southwest corner of the county. He waxed poetic, describing the area as an "exceeding rich land, full of large trees, with vines married to them." That evening they camped at another nearby stream or creek. "We marked out our quarters on the bank of a purling stream, which we called Casquade Creek, by reason of the multitude of waterfalls that are in it." Today the name is spelled Cascade and denotes the far end of Pittsylvania County.

When Byrd returned to the area in September 1733, the party camped near Banister River, which cuts west to east across Pittsylvania and meanders on into Halifax County. Byrd wrote, "We rode through charming lowgrounds… to a larger stream…we agreed to call Banister River." With the group was Mr. John Banister, namesake of his famous father, an English clergyman and scientist who published the first descriptive accounts of Virginia's natural history relating to botany and entomology. The elder Banister had accompanied Byrd on his first trip but was accidentally killed. Byrd no doubt named the river after him.

Taking all of the explorers' and traders' insights together, the area in and around Pittsylvania County, Virginia, was revealed as a cornucopia of minerals, rich soil, wildlife and plant life, including grazing land and hardwood forest. The Piedmont's resources, Byrd suggested, had the potential for raising cattle, establishing vineyards and orchards, mining valuable metals and growing crops such as cotton, hemp, rice and others on lands as fertile as those of ancient Babylon. After surveying the lands along the county's southern border into North Carolina, Byrd was convinced that "everything will grow plentifully here to supply either the wants or wantonness of man" and that families could "pass their time very happily there."

CHAPTER 4

COLONIAL SETTLERS

The explorations of the Piedmont and the Blue Ridge paved the way for settlement of these lands. The explorers saw, along with trappers and traders, the exotic beauty, but most of all they saw the possibilities of life beyond Virginia's coastal plain. As the Tidewater experienced an influx of immigrants and as those already there sought more land, settlers spread out toward the Piedmont and the mountains.

Virginia governor Alexander Spotswood's 1716 expedition, with companions dubbed the Knights of the Golden Horseshoe, traveled through the Piedmont and viewed the Blue Ridge Mountains. Afterward, his goal to encourage settlement of Virginia's western land resulted in two new counties, Spotsylvania and Brunswick. Pittsylvania lands fell within those of Brunswick, which stretched from the fall line of the James River to the mountains.

Louis Ruben, in *Virginia: A Bicentennial History*, revealed that the liberal land grant policy of Governor Gooch, Spotswood's successor, also helped propel migration to western lands. When Gooch was appointed in 1727, Virginia was divided into twenty-eight counties, and by the time he completed his tenure in 1747, counties totaled forty-four—a result of Virginia's growth and migration westward.

As the region grew it was subdivided, and Pittsylvania County came to be its present size. *Eighteenth Century Landmarks of Pittsylvania County* describes the county's "family tree":

Colonial Settlers

When Pittsylvania was born in 1767, it was a child of Halifax, of which it was a part from 1752 to 1767, and a grandchild of Lunenburg, of which Halifax was a part until 1752. Prior to that, from 1720 until 1746, it was called Brunswick. Furthermore, Pittsylvania had children. When it was reduced to its present size in 1777, it gave birth to Henry, which has subsequent issue of Patrick and part of Franklin.

When Pittsylvania County was a part of Brunswick, William Byrd, explorer and land speculator, had high hopes for the land areas that he had surveyed to mark the Virginia/North Carolina line. *The Calendar of Virginia Papers* indicates that in June 1735, Byrd petitioned the Virginia Council for a huge land grant with the explicit purpose of settling immigrants. The council order read in part:

On the Petition of Wm Byrd Esqr. sett forth that he speedily Expects a Number of Switzers, and other foreign Protestants to come over to this County & praying that 100,000 Acres of Land may be granted him for their Accommodation & Settlement, to be taken up in one or more Tracts on both Sides the South Branch of Roanoke River, Between Birches' Creek & the River Irvine.

Dan River is the lower branch of the Roanoke River with Birch Creek being in southeastern Pittsylvania County and the Irvine River, now the Smith River, located beyond the county's present borders. Byrd's land grant would have included the southern part of Pittsylvania County.

Mechal Sobel, in *The World They Made Together*, believes that Byrd considered himself the archetype of the biblical patriarch and hoped to develop his lands into an "urban and rural paradise." On Byrd's 1736 map titled *Eden in Virginia*, Byrd illustrates his vision for towns along the Dan River in Virginia, including a sketch of a town layout.

It is doubtful that any European settlers were living in Pittsylvania County when William Byrd came through on his survey of the Virginia/North Carolina border in 1728. But his promotion of his newfound "Eden" got the word out.

The desire for land by well-heeled planters such as Byrd and struggling pioneers created a culture clash with the Indians. The Virginia Historical Society, in an article titled "The Story of Virginia: An American Experience," concluded that "although there were cultural misunderstandings,

competition for land was the main cause of conflict between the English and the Indians."

Settlers who populated Virginia in the Tidewater and beyond into the Piedmont and the mountains had no trouble justifying their takeover of Indian lands. In *Old Dominion, New Commonwealth 1607–2007* by Ronald Heinemann and others, the authors state:

> *With their eyes on riches, the settlers justified taking the property on grounds of cultural superiority. They believed the Indians lacked a concept of private property…underutilized the land, were irreligious or heathen, and, although intelligent, were a culturally deprived people with benighted souls whom the English could civilize and Christianize and teach the appropriate use of land.*

With the decimation of the Indians by war and diseases, aided by the encroachment of European settlers, the Native Americans of Virginia were greatly reduced in number by 1700. The early settlers of Pittsylvania County who came here three decades later did not encounter any Indians. What they did encounter were the remains of a once thriving civilization in ruins. The book of surveys at Pittsylvania County Courthouse during this period of settlement is rampant with references to remains of Indian fields, forts and towns as markers and descriptive phrases relating to boundary lines.

Even more settlement was encouraged by a legislative order in November 1738. All settlers who came to settle the land between the north and south branch (Dan River) of the Roanoke River known as Brunswick County would be exempted from all levies for ten years. Settlers coming from the east probably followed the Occaneechi Trading Path from the James River westward and Indian paths that ran near Routes 57 and 40, both of which go east to west through Pittsylvania County. During the 1730–40s, Scotch-Irish, German and Quaker settlers had begun their treks from Pennsylvania down the Great Wagon Road, which today is roughly Route 220 from Roanoke. These migrants populated the Valley of Virginia and moved east of the mountains into the foothills, filtering into Pittsylvania County.

In 1738, Quakers Isaac Cloud, his son Isaac Jr. and Joseph Cloud migrated from Pennsylvania and settled on land along Banister River. Daniel and Gideon Smith arrived in 1740, and it is likely that Smith Mountain in the northwestern part of Pittsylvania and the Smith River were named after

Colonial Settlers

them. Scotch-Irish settlers such as John Stuart settled near Sandy River in 1738; Peter Wilson built a plantation on Dan River along with a ferry; and David Logan settled along Elkhorn Creek in the Spring Garden area. German immigrants Thomas and Tasker Tosh are still remembered by the small community of Toshes. Others came from eastern Virginia and Maryland. William Wynne migrated from eastern Virginia, and his entry for land in Pittsylvania is recorded for June 1738. Wynne's Falls on the Dan River, named after him, later became Danville.

John Pigg migrated from Amelia County in 1741, and the south fork of the Staunton was later named Pigg River after him. In 1741, Benjamin Clement of Amelia County entered for land along the Staunton, and in 1743 Thomas Calloway of Caroline County built his home in the same area. From Maryland came Robert and Edward Sweeting, for whom Sweden Fork Creek in the Spring Garden area is most likely named.

From Accomack County on Virginia's eastern shore came John Donelson in 1744 with his wife Rachel Stockley and their belongings and several slaves. He patented two hundred acres on both sides of Sandy Creek and later built a home along the Banister River. Today this community is known as Markham after later plantation owners. The exact location of his home in view of the Markham Bridge is designated today with a ceremonial chimney and a plaque recognizing the site. Donelson rose to prominence in Pittsylvania County, holding leadership positions from county surveyor to member of the House of Burgesses. Later he became one of the founders of Tennessee.

During the 1740s and 1750s, land records show that many people settled along the major rivers and tributaries, such as Dan River, Banister River, Sandy Creek, Sycamore Creek and Turkey Cock Creek. Turkey Cock Mountain nearby, as well as the creek, received its name from the large flocks of turkeys in the area. Harmon Cook, a large landowner in the county with 3,253 acres around Tomahawk Creek and Pigg River, helped colonize the county by bringing in settlers from Pennsylvania.

In 1748, Samuel Harris of Hanover County patented land near Sandy River and built his home overlooking Strawberry Creek. He became a leading county citizen, holding several public offices and military positions, and he was also one of Virginia's most famous ministers. He established the first Separatist Baptist Church in Virginia and had such influence on establishing the Baptist Church throughout the state that he was appointed "Apostle of Virginia." It was said of him that "there is hardly any place in Virginia in which he did not sow the Gospel seed."

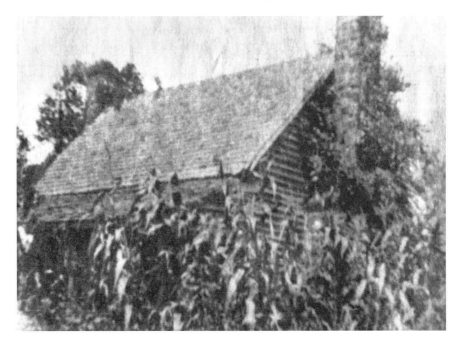

This was the home of John Donelson located in the Markham community. Donelson, a prominent county citizen, built this mansion house, which no longer exists, along the banks of the Banister River after he arrived here around 1745. *Photo courtesy of Desmond Kendrick.*

A list of first tithables of Pittsylvania County in 1767 listed Harris with 757 acres and seven Negroes.

One of the earliest settlers of Pittsylvania was Captain William Bean Jr., who had bought some of William Byrd's land. Bean lived in what later became known as Wenonda—a community once located west of Danville in the Brosville area on the north side of Dan River. He and wife Lydia Russell (sister of George and John Russell of Pittsylvania County) and their large family moved from Pittsylvania County and went into the wilderness of what is now Tennessee, where no other soul lived. Bean had heard of the beauty and bountifulness of the country from hunters and trappers and had explored there himself with Daniel Boone. Bean was not alone for long in that vast wilderness, but the history of Tennessee essentially begins with his family. His son Russell became the first white child born in the state.

Sally Hairston, who grew up on the old Oak Hill plantation home of her ancestor, Samuel Hairston, on what became Berry Hill Road off Route 58 West, remembered a tradition passed down in the family about William Bean. The long hunter's first home or hunting camp remained on the Oak

Colonial Settlers

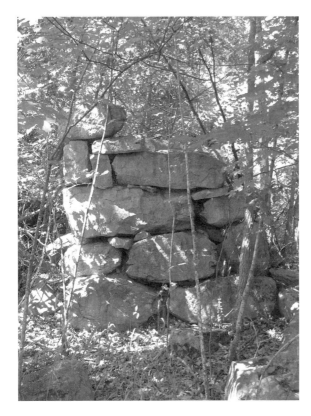

The remains of this rock house, located near the former community of Wenonda, are believed to be the hunting camp or home of William Bean, who settled Pittsylvania County in 1743.

Hill property and was left standing out of respect for Bean. The partial remains of the structure still stand on the property today, with evidence of a fireplace and suitable living quarters.

Another adventurer, Elisha Walden, a long hunter who explored Tennessee and Kentucky, received four hundred acres on Cherrystone Creek near Chatham in 1745. In that year, Brunswick County's western part was formed into the new county of Lunenburg due to the influx of settlers.

Peter Perkins is listed with 1,200 acres on Cascade Creek in 1768. Perkins's family had purchased some of the land from William Bean when he moved to Tennessee. The Perkinses' home still stands with its place in history secure for the role that Colonel Perkins and his house played during the American Revolution. Perkins also became a member of the House of Delegates, Pittsylvania county sheriff, justice of the peace and vestryman.

George Jefferson and his brother, Peterfield Jefferson, close cousins of Thomas Jefferson, both bought land in Pittsylvania County. A list of tithables for Pittsylvania County in 1767 listed George with eight thousand acres and Negro slaves Sam, Chance, Pompey, Phillis, Pat and Sary. Peterfield Jefferson,

who had purchased land from his brother, made his home on Turkey Cock Creek in the county.

With the influx of settlers increasing the population, roads were an absolute necessity in order to connect the county's different regions. The court appointed surveyors and required them on pain of fine to use the tithables in their area to lay out the road. Of course, slaves were a main source of labor.

The very first road in Pittsylvania was built from William Bean's on the Dan River. The Lunenburg County Order Book entry for March 3, 1746, ordered

> *that a Road be laid off and Cleared from William Bean's on Dan River the best and most Convenient way to Banister* [Town] *from thence the best and most Convenient way to the North River at Cargill's Horse Ford, and from thence the best and most Convenient Way to this* [Lunenburg] *Courthouse.*

The road stretched from Dan River near Brosville to Sandy River near Danville to Double Creek in the southeastern part of Pittsylvania County. From there it continued to the town of Halifax near South Boston and then westward. Several other residents, including William Wynne, were ordered to survey and clear the various sections of the road. Two other roads were ordered to be laid off from Bean's house, the last one being in 1753 stretched to the new courthouse in Peytonsburg before Pittsylvania separated from Halifax in 1767.

In June 1749, Hickey's Road led from the Staunton River in Halifax County by Mount Airy in the northeastern part of Pittsylvania, then by Chalk Level and Chatham, proceeding westward across Banister River and then proceeding into what is now Henry and Patrick Counties. John Hickey's store was at its western limit, a distance of over a hundred miles from the beginning.

In 1760, John Ward and Benjamin Clement were ordered to lay off a road from Ward's Mill to the Pocket Ford on the Staunton River. It led from Reedy Creek in Pittsylvania County below Altavista, continued up the south side of the river and passed Clement's home near the mouth of Sycamore Creek. Later known as Ward's Road, it became a major thoroughfare for tobacco.

By 1762, Ward had received license to operate a ferry at the river crossing. On the south side of the river in Pittsylvania County was the location of

Colonial Settlers

This section of Route 937 is part of the original Hickey's Road in Pittsylvania County. Laid out in 1749, it stretched over one hundred miles from Staunton River in the northern part of the county to the western part of Patrick County.

his tavern and on the opposite side of the river lay his home, the Mansion. Crossing the river at that point today near the community of Grit is a bridge, naturally called Mansion Bridge, which leads into Bedford County.

The first roads were primitive affairs, but they provided access to the county courthouse, neighbors and markets. Roads further joined and promoted developing settlements with their stores, taverns and ordinaries, the latter many times set up in someone's house. The most well-known store was probably that of Samuel Calland, located at the site of the 1767 courthouse.

Calland's store, like the others, became conversation stations—gathering places where neighbors came and went, exchanging gossip, discussing politics and purchasing goods. The store was located off what is now Route 57, where Callands's clerk's office and the first Pittsylvania Courthouse are both located and restored. He sold everything imaginable to settlers, long hunters and others passing through. Frances Hurt writes, "The store became famous, for it not only sold necessities for the frontier, but also the finest imported goods—silks, linens, laces, ribbons, combs." Most anything from shoe buckles to fine china to farming tools could be bought there.

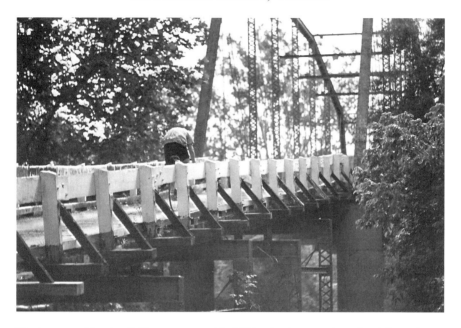

The iron truss Mansion Bridge, constructed in 1903, takes its name from the eighteenth-century home of John Smith that was located nearby this Staunton River crossing.

In 1767, when Pittsylvania County took its name, men who would later figure prominently in the Revolutionary cause became the new justices. They were, according to J.A.C. Chandler in *Life in Old Virginia*, selected from "the best citizens of the county—the dignified, educated and often wealthy gentlemen." Among them were Thomas Dillard Sr., James Roberts, Archibald Gordon, Thomas Dillard Jr., Hugh Innes, John Donelson, Theophelus Lacy, John Wilson, Peter Copeland, John Smith, John Dix, Peter Perkins, John Wimbush, Benjamin Lankford and George Jefferson, a cousin of Thomas Jefferson.

Among the justices in 1767, two became county officers: Benjamin Lankford was chosen sheriff, and John Donelson, surveyor. William Tunstall became county clerk, with his son and grandson following him. Three generations held the office for a total of eighty-three years.

As the county was organized, the justices took the first census. Pittsylvania's first list or census of tithables in 1767 totaled 1,254, listing 938 whites and 316 slaves. By 1773, the population had nearly doubled to 2,198 tithables, indicating that migration had vastly increased the population. However, the tax lists of tithables were not a true population count, for they included only

Colonial Settlers

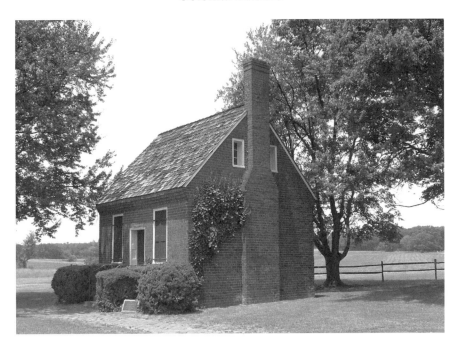

This building at Callands, Virginia, served as Pittsylvania County's first clerk of court's office from 1771 to 1777.

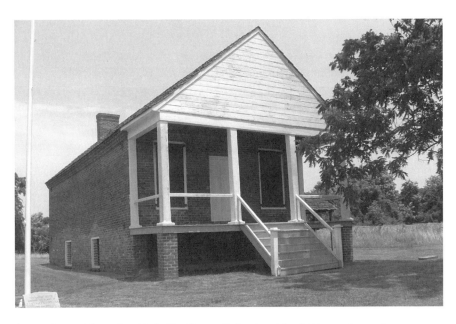

Across the road from the old clerk's office at Callands, with a jail beneath, stands Pittsylvania's first courthouse, used until 1777. It later served as Samuel Calland's store and post office.

white males sixteen years and older, all slaves sixteen years and older and widowed women who were heads of household.

Some of the justices became vestrymen as Camden Parish was organized. At the courthouse on June 21, the vestrymen subscribed to the Doctrine and Discipline of the Church of England. They were responsible for selecting the minister, precessioning or remarking boundary lines every four years, locating churches and chapels, arranging for worship throughout the county and caring for the poor. The vestry also managed the taxes collected to support the church and imposed discipline for lapses in morality. In those days, separation between church and state did not exist. In fact, people were required to attend church and provide financial support for it. In 1624, Virginia law defined in *Hening's Statutes* declared

> *that whosover shall absent himselfe from divine service any Sunday without an allowable excuse shall forfeite a pound of tobacco, and he that absenteth himselfe a month shall forfeit 50lb. of tobacco…That no man dispose of any of his tobacco before the minister be satisfied, upon paine of forfeiture double his part of the minister's means, and one man of every plantation to collect his means out of the first and best tobacco and corn.*

The county justices were an equally powerful body. The justices held court each month to issue marriage licenses, plan and order roads and determine taxes. When Pittsylvania was part of Halifax in 1752, "a tax of twenty-one pounds of tobacco was laid upon each tithe, that is on each white male eighteen years and over, and upon each slave of sixteen years and over."

The court also governed tavern prices. Frances Hurt, in her *Intimate History of the American Revolution in Pittsylvania County, Virginia*, lists the Pittsylvania court order for 1767 that set the prices of liquor, food, lodging and fodder. Lodging per night cost six pence, a hot breakfast and dinner one shilling each, a stable for a horse per night six pence, a bottle of Madeira wine five shillings, a gallon of West Indian rum ten shillings, a gallon of whiskey six shillings, a bottle of English beer one shilling six pence and so forth.

Offenses dealt with by the court were swearing one, two or three oaths, drunkenness, selling liquor contrary to law and allowing slaves to work on the Sabbath. The justices resisted any disrespect to the dignity of their office. In August 1767, the Pittsylvania court decreed, "William Astin having insulted Mr. Justice Innes in the execution of his office, he is fined 10 pounds."

Colonial Settlers

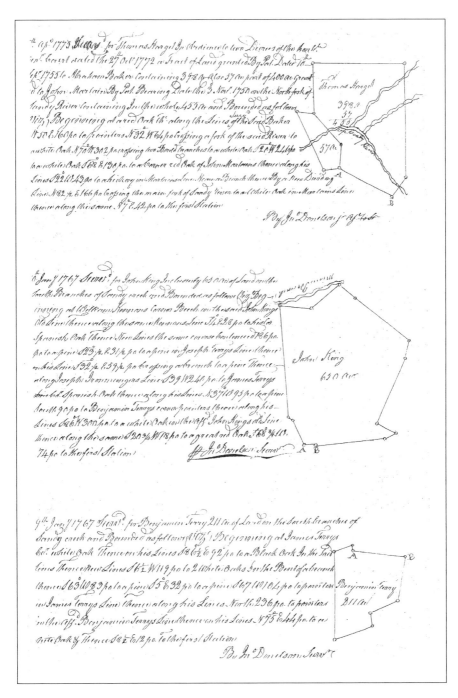

Land surveys from the old survey book in the clerk's office in Chatham as recorded by John Donelson, the county surveyor, and his son, John Donelson Jr., assistant surveyor, with descriptions and maps dated 1767 and 1773.

Not even court justices were exempt from the law. James Roberts Jr. was appointed a justice of Pittsylvania County when it was formed in 1767. He had built the courthouse in Peytonsburg when it was part of Halifax County. As soon as the court met in June 1767, it was ordered that the next court be at the plantation of Roberts on Sandy River, a location now called Callands.

Roberts got too busy with his ambitions to deliver on time. He established a gristmill on Sandy River, received license to operate an ordinary, continued to patent land to the amount of four thousand acres and became sheriff in 1769. The March 1770 court responded to this delay and gave him two months to complete the courthouse or be prosecuted.

He probably devoted considerable time to the courthouse then because by July 1770 he was fined five shillings by the court for his lack of "strict and diligent attendance on the business of this county" in his position as sheriff. He finally built the courthouse, but other legal troubles followed unrelated to the courthouse and Roberts went bankrupt.

The courthouse debacle, and the ensuing problems with its builder, was a sad story accompanying the new county, but it did not change the upward direction of Pittsylvania. What started out as unexplored frontier territory later became the home of a few people with no roads but Indian paths. As Scotch-Irish, German, Quaker and Tidewater settlers moved into the Piedmont, Pittsylvania grew into a thriving community by 1767, with roads, stores, taverns, a new courthouse, ferries, gristmills, an organized government with court and county officials and a militia that would fight the French and Indian War and then challenge the Lords of London in the Revolution.

That was just the beginning.

Chapter 5

A Gathering Storm

While Pittsylvania County was still part of Halifax and migrants were finding their way to the area, a continual pattern of conflict took place between the king and the Virginia legislature. In the 1750s, the king had overruled the Virginia legislature more than once in situations that related to the colony's internal affairs. Then he declared the land west of the mountains and trade with the Indians off-limits after the French and Indian War concluded in 1763.

In order to pay for that war, the British Parliament passed a series of disagreeable acts that encouraged Boston merchants to boycott British goods. The crisis intensified as Parliament passed the dreaded Stamp Act in 1765, requiring the colonists to pay taxes to England for the first time and not to their own legislatures. As expected, it caused a firestorm, and Pittsylvania County was no less upset than the rest of America.

In Parliament, English statesman William Pitt, the Earl of Chatham, railed against the Stamp Act, which was enacted by Parliament while he was sick at home. He denounced this unfair trampling upon the colonies with the words, "In my opinion this kingdom has no right to lay tax on the colonies. America is obstinate. I rejoice that America has resisted; three million people so dead to all feeling of liberty, as to voluntarily submit to be slaves, would have been fit instruments to make slaves of the rest."

Pitt often found himself in opposition to the king's policies and time and again defended the colonies' rights to the fundamental liberties of Englishmen. The Stamp Act was repealed in February 1766 largely through his efforts,

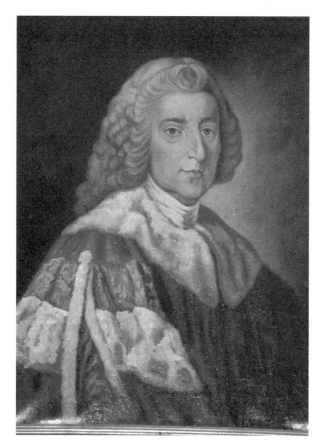

This portrait of William Pitt, the Earl of Chatham and member of the British Parliament, hangs in the Pittsylvania County Courthouse in Chatham, Virginia. The county and county seat were named after him for his staunch support of the colonists before the Revolutionary War.

but the damage was done. The resolve of the king and Parliament, as well as that of the American colonists, began to harden. The British Parliament would pass more acts and more resistance would follow.

An indication of the feelings of the inhabitants of Pittsylvania County came on June 1, 1767. On that date, it was separated from Halifax County and took its present name in honor of William Pitt for his support of the colonies. Years later, the county seat would be named Chatham after Pitt's title.

On June 29, 1767, the same month that Pittsylvania County took its name, the Townshend Revenue Act was signed by George III and taxed glass, paper, paint and tea. This led to a boycott of British goods by Boston and New York merchants in 1768 and by Philadelphia in 1769, followed by Virginia.

When Lord Botetourt became Virginia's new royal governor in 1768, he called for the election of burgesses. Justice John Donelson, Pittsylvania

A Gathering Storm

County surveyor, and Justice Hugh Innes, a lawyer, represented Pittsylvania and met with the other delegates in May 1769 at the capitol in Williamsburg for the opening of the Virginia General Assembly. Among the burgesses were signers of the future Declaration of Independence, including future presidents George Washington and Thomas Jefferson.

In the ornate Governor's Palace in Williamsburg, the governor no doubt hosted elegant balls and extravagant socials, complete with fine silver settings, fashionable displays of foods, choice wines, dancing and suitable toasts to King George III. Botetourt's arrival at the opening session of the legislature was a stylish affair, as he appeared in a stagecoach given him by the king and drawn by six milk-white horses. He opened the assembly with all the formality of the British Parliament in London.

Despite all the pomp and circumstance and his elaborate display of power, the assembly was not moved and passed a set of Virginia Resolves objecting to the transport of rioters in Boston to England for trial and also asserted "the sole Right of imposing taxes on the Inhabitants of this his Majesty's Colony and Dominion of Virginia is now, and ever hath been legally and constitutionally Vested in the House of Burgesses."

These actions highly displeased the governor, who summoned the House of Burgesses to his council chambers. He promptly dissolved the Virginia General Assembly, saying, "Gentlemen, I have heard of your resolves, and auger ill of their effects. You have made it my duty to dissolve you, and you are dissolved accordingly."

Not to be deterred by the governor's rejection, the House of Burgesses retired to Raleigh Tavern and organized a Non-Importation Association supporting the boycott of British goods until the tax on paper, tea and glass was removed. The members drew up a document with eight resolves, which was signed by those present, including Virginia's leaders Washington, Jefferson, Richard Henry Lee, George Mason and Patrick Henry. Affixing their signatures alongside those of our Founding Fathers were Pittsylvania County representatives John Donelson and Hugh Innes.

Less than a year later, on March 5, 1770, the Boston Massacre took place, and by the next month the Townshend Acts were repealed. Duties on imported products from England were eliminated—all, that is, except the tax on tea. That tax was left as a gesture demonstrating to the colonies that Parliament had the right to tax all British subjects.

In the next several years, tensions with the British government escalated even more among the Virginia colonists. One such event in Pittsylvania County, which at first appearance had nothing to do with the ongoing crisis

concerning Great Britain, turned out to be once again an arbitrary abuse of power by the royal governor.

Douglas Southall Freeman, in his monumental *George Washington, A Biography*, tells us the story, describing it as "one of the strangest disasters that had been visited upon Virginia." In January 1773, the Virginia state treasurer, while examining some five-pound paper money notes issued in 1769 and 1771, noticed that they were "well-executed counterfeits." A few days later, he discovered fake one-pound notes. To protect the colonists, he published a warning and description of the forged notes in the *Virginia Gazette*. The announcement sent shock waves throughout the state and business nearly came to a halt.

Learning that the forgeries originated in Pittsylvania County, Governor Dunmore exercised his authority as titular chief justice of the General Court and issued warrants for the arrest of the perpetrators. He sent Captain John Lightfoot to Pittsylvania County, where he caught the counterfeiters in the act. Theirs was a first-class operation, complete with engraving tools, dies, papermaking frames, a rolling press and a large number of counterfeit five-pound notes.

Captain Lightfoot returned to Williamsburg February 23 with the following culprits under heavy guard: Benjamin Cooke, Joseph Cooke, James Cooke, Benjamin Woodward and Peter Medley. Other suspects fled the scene before they could be arrested. The men were jailed in Williamsburg with another suspect, Moses Terry, who confessed and became a witness against the others. Thereafter Governor Dunmore summoned the legislature to assemble and subsequently, on March 4, 1773, mentioned his arrest of the counterfeiters in his remarks to the House of Burgesses.

While the burgesses, John Donelson and Hugh Innes of Pittsylvania County among them, applauded the governor's actions of bringing the forgers to justice, they took strong exception to his methods. In doing so he had totally disregarded the Court of Pittsylvania County and had removed the prisoners to surroundings far from home to be tried by people who did not know them. The assembly was upset because the governor had done the same thing that the British Parliament and king had tried to do in sending supposed troublemakers from Boston to England for trial, usurping the rights of the local citizens and their governing bodies.

Wearied by like provocations from the British Parliament and its royal governor, Boston colonists tossed tea from British ships into the harbor, and by March 1774, in response, the English Parliament passed the Coercive or Intolerable Acts. They shut down Boston Harbor until the tea was paid

A Gathering Storm

for and subjected Massachusetts to military rule. Other tyrannical acts followed—the most distasteful one required the American colonists to house British troops.

When news of the Boston Port Bill closing Boston Harbor reached Virginia, its assembly, with Pittsylvania County burgesses included, called for a day of prayer and fasting to support the people of Boston. Governor Dunmore promptly dissolved the legislature. Once again members gathered at Raleigh Tavern. Among other things, they supported a general boycott of all British goods and declared their unwavering support for the actions of Massachusetts citizens. Foremost, the burgesses, with Pittsylvania County well represented by Peter Perkins and Benjamin Lankford, agreed to call for a Continental Congress with representatives from all colonies. Through Virginia's influence, it was held on September 5, 1774.

The Continental Congress set up a Continental Association, which was responsible for enforcing the boycott of British goods. Towns and counties in every colony were to organize Committees of Safety to punish those who violated the boycott.

As the contention between Britain and its colonies rose to a fever pitch, the first battle of the Revolution took place—against the Indians, no less—and Pittsylvania County Militia joined in. It was a culmination of many years of Indian problems related to their lands. Despite George III's attempt to prevent settlement beyond the mountains, settlers went there anyway, and this encroachment into native hunting grounds became a source of conflict. In 1770, John Donelson of Pittsylvania, a member of the House of Burgesses, had become Virginia's official representative to the Cherokee chiefs at a conference in Lochabar, South Carolina, that concerned boundary lines. In 1772, Donelson was authorized to extend the Virginia/North Carolina boundary survey begun by William Byrd in 1728 to the land west of the Blue Ridge. He then met with the Indian chiefs at Long Island on the Holston River for their approval.

These attempts to mollify the Indians never resulted in satisfactory solutions, and controversy with the Indians became full blown in 1774. In August, a *Virginia Gazette* story reported that several families had been attacked along Pittsylvania County's southern border with North Carolina by Choctaw, Shawnee and Delaware. The county requested arms and ammunition from the governor.

The continued terror on the frontier prompted Governor Dunmore to finally declare all-out war on the Indians. He instructed General Andrew Lewis of Salem, Virginia, to move toward the Ohio River with one thousand

men and meet him with an equal number and together attack the Indian towns on the river.

Several militia companies from Pittsylvania County assisted Lewis. But before Lewis's forces met with Dunmore's, Lewis battled the Indians at the Ohio and defeated them on October 10, 1774. This has been called the first battle of the Revolution simply because of the British-inspired Indians' molesting and murdering of settlers along the frontier.

With the Indian problem settled for the time being, on January 25, 1775, Pittsylvania selected its Committee of Safety, consisting of thirty-one men, the most reputable in the county. On February 11, 1775, the *Virginia Gazette* reported that Pittsylvania County chose its committee

> *for enforcing and putting into execution the Association...and all the inhabitants then present (which was very numerous) seemed determined and resolute in defending their liberties and properties, at the risk of their lives, and if required, to die by their fellow sufferers* [the Bostonians] *whose cause they consider their own.*

No sooner had the Committee of Safety been elected than April 1775 arrived with the shots "heard 'round the world" at Lexington and Concord in Massachusetts, followed by the Battle of Bunker Hill. The war was on, even though independence had not yet been declared.

The Committees of Safety were to direct military affairs as ordered by the Virginia Convention of July 1775, which authorized two regiments of one thousand men each for the northern army of George Washington. Pittsylvania County contributed one company of Minutemen under Captain Thomas Hutchings and Lieutenant James Conway.

The military strength of Pittsylvania was assessed at 1,438 men, who were organized into 27 companies of 50 men each. Every man had to bring his own gun and munitions plus other equipment and be prepared to drill every two weeks and attend a general county muster in April and October. Among the militia was a company of sharpshooters under the command of Captain Thomas Dillard.

On September 27, 1775, John Donelson was nominated for county lieutenant; Robert Williams, colonel; William Tunstall, lieutenant colonel; John Wilson, major; and among appointed captains were men such as Benjamin Lankford, Peter Perkins, John Donelson Jr., Joseph Martin, John Dix and William Witcher—men already familiar to and who enjoyed the high respect of county residents.

A Gathering Storm

These spurs belonging to George Washington's brother, Colonel John Washington, were acquired by the Pittsylvania County Historical Society from Lawrence Washington, a descendant.

According to Maud Clement, it was about this time that Captain Benjamin Clement of Pittsylvania County made the first gunpowder in the Virginia Colony. He lived at "Clement Hill" south of the Staunton River, which forms Pittsylvania's northern border. With the help of Colonel Charles Lynch, who lived across the river in what is now Campbell County, the two were later able to turn out fifty pounds of powder a day. With a block on imports from England, this was a significant source of powder for the Revolutionary cause, a fact recognized by the Continental Congress, which sent its agent to the operation.

In January 1776, the Committee of Safety continued organizing the county but Indian attacks again increased. Uprisings in North Carolina brought a plea for help. The Pittsylvania Militia companies of Captains Peter Perkins, Thomas Dillard, William Witcher and Joseph Martin set off on the Southern Expedition against the Indian strongholds three hundred miles away in Tennessee.

The Indians were gone when the men arrived, but the Indian problem did not go away. In 1777 and 1778, during the war with Great Britain, Captains John Donelson Jr. and William Witcher marched their companies to Fort Patrick Henry on Long Island on the Holston River, but no Indian atrocities occurred. In 1778, Captain Thomas Dillard's company went to Boonsboro, Kentucky, in January, and by July some of those men went on with Colonel

George Rogers Clark to Illinois to capture British outposts Vincennes and Kaskashia. Pittsylvania County Militiaman James Irby died on that march.

As the country drifted closer to a full-scale war with Britain, the Committees of Safety, especially in Pittsylvania County, became very zealous about enforcing the association's orders in sniffing out British sympathizers. Having pro-British sentiments was enough to have someone brought before the committee, and if no satisfactory explanation could be given, the person's name was published in newspapers as "inimical to the cause." This would serve to isolate the person from family, friends and neighbors. Wealth and social position were no protection.

Even tea was off-limits. Maud Clement writes, "The drinking of tea was banned; to partake of the beverage was considered a virtual act of treason." And the committee was also strict in its enforcement of that policy.

One such case in Pittsylvania County had to do with Captain John Pigg, an early settler. He had been appointed a vestryman and a captain in the Pittsylvania Militia. He was reported to the committee for "drinking and making use of in his family, the detestable East Indian tea." In May 1776, the committee ordered him to appear before them. Captain Pigg refused to appear because he considered this action an interference in his family affairs. Not intimidated, the committee had his name published in the *Virginia Gazette*, effectively branding him disloyal to the cause.

The Pigg affair showed others that in Pittsylvania County being loyal to the king of England came with a price to pay. But the Declaration of Independence was around the corner, and in future days those who declared themselves for freedom from tyranny would risk their lives, homes and fortunes. Worse, they stood to be tried for treason and hanged. That fate must have weighed heavily on the leaders and citizens in Pittsylvania County.

Chapter 6

The Road to Yorktown

If no road led directly from Pittsylvania County to Yorktown, the high-water mark of the American Revolution, it should have. The county was involved in every aspect of the cause, though it was not the site of any major battle. From the first battle of the Revolution in Ohio to the last major battle at Yorktown, Virginia, soldiers from Pittsylvania County enlisted and served the Patriot cause.

On May 15, 1776, two months before the Declaration of Independence was signed in July, the Virginia Convention voted to sever ties with Great Britain. Joy echoed throughout the capital at Williamsburg with a parade of troops buoyed along by discharging cannons and guns and general revelry. It was truly a *feu de joie* as excitement spread throughout the colony.

While the war raged between the British and American armies in the North, and while Pittsylvania County soldiers also defended the frontier against Indian attacks in the West, a petition filed with the General Assembly received approval to reduce the size of the county to its present dimensions. Its great size had become a problem since it stretched from the Halifax County line to the Blue Ridge. The petition mentioned that people "were so often called together to the Courthouse on account of our unhappy disputes with Great Britain, being ready and willing to do all in our power for our just rights and liberties."

On January 1, 1777, Pittsylvania County became its present size. Among the eighteen new justices were some familiar faces: John Donelson, James Roberts, Crispen Shelton, Thomas Dillard, Peter Perkins, Benjamin Lankford,

William Witcher, Abram Shelton, John Dix and, in addition, Reuben Payne, Daniel Hankins, John Wimbish and William Short. In the July court, they agreed to establish a courthouse near the Cherrystone Meetinghouse Spring near Hickey's Road in the ravine where Depot Street now follows.

The justices were also charged with compiling a list of those who took the Oath of Allegiance to the commonwealth, which had been passed by the General Assembly in May 1777. To investigate disloyalty to the new nation and Virginia as a free state, Courts of Inquiry in each county included members of the Committee of Safety and militia officers. Ordered to appear before the court were Reverend Lewis Guillian and Samuel Calland, to see "why they do not depart this colony, they being natives of Great Britain." Reverend Guillian, the minister of the Church of England, never did appear and left the county, which would not be surprising since the good reverend was a Church of England minister.

The tale of Samuel Calland's refusal has an interesting twist. The minutes of a committee held for the County of Pittsylvania at the courthouse the twenty-second day of July 1776 read:

> *This Committee being informed that George Herndon, George Murdoch, John Mack, Samuel Callan, Zachariah Smeed, William Mitchell, and Archibald Smith, are suspected to be enemies to the rights and liberties of America, they having appeared before this Committee agreeable to citation, refused to take the oath prescribed by the General Convention: Whereupon, it is Ordered, That the Clerk do transmit a copy of these proceedings to Mr. Alexander Purdie, that the same may be inserted in his Gazette.*

Samuel Calland, though he refused to take the oath, had married Elizabeth Smith of the Pocket Plantation and settled at Turkey Cock Mountain near the village of Chatham. Since his wife was a native of the county, Calland received permission to stay. Others of his family took the oath, and later Samuel Calland finally did also. By 1777, Calland had opened his store in the courthouse building since court was moved to the Cherrystone Meetinghouse site. The area around the store finally took on the name "Callands" since the Scottish merchant Samuel Calland's store became a centerpiece of county life. In 1790, he was appointed a county justice, proving himself to be fully redeemed.

Although Samuel Calland received a reprieve from taking the oath since he had married a county native, others were not so lucky, for those who refused the oath were not allowed to own guns and their property was

The Road to Yorktown

Callands Autumn Potpourri 2001, an annual festival celebrating Pittsylvania County's colonial heritage. *Photo courtesy of* Star-Tribune.

confiscated. Abram Shelton, escheator for Pittsylvania County, appraised and sold at public auction properties owned by British subjects such as John Smith, Murdock and Company, James Smith and also Archibald Smith, mentioned in the minutes above.

While the county dealt with loyalty oaths and Tories, Pittsylvanians also participated in nearly every major battle of Washington's army from 1776 to 1778. When the joy of independence turned into a struggle for survival by December 1776, General George Washington, in a brilliant and audacious move, made his famous crossing of the Delaware that scored a gigantic victory over the British at Trenton. Pummeled by snow and sleet as they marched to the ice-laden river, two Americans froze to death on the march, one being Pittsylvania County Continental soldier Lieutenant James Conway. He had been with Captain Hutchings's Pittsylvania Company at Williamsburg when the Virginia legislature voted for independence. While there, the company's enlistment term expired, but Lieutenant Conway and others reenlisted and later served in Washington's army. Pension applications also place Pittsylvania County soldiers with Washington's army during the winter at Valley Forge and at the Battles of Brandywine, Germantown and Monmouth.

By 1780, the war was not only becoming unpopular in America but also in England, especially in Parliament. While Tory or Loyalist sympathies were held in check in the county by the Committee of Safety and Court of Inquiry, there had been growing dissension in other parts of the state where Tory leaders had been plotting insurrection. By late 1780, Pittsylvania County became susceptible. Thomas Jefferson wrote a letter dated October 27, 1780, stating:

> *A very dangerous insurrection in Pittsylvania was prevented a few days ago by being discovered three days before it was to take place. The Ringleaders were seized in their beds. This dangerous fire is only smothered: When it will break out seems to depend altogether on events. It extends from Montgomery County along our southern boundary to Pittsylvania and eastward as far as James River.*

Despite the Tory problem, it was also the time of the greatest contributions of Pittsylvania's soldiers and citizens to the Revolutionary War in the Southern Campaign of 1780–81. The British, who had been

This comment about Pittsylvania County appeared in a 1780 letter by Virginia's governor Thomas Jefferson that related details of a Tory plot, which was discovered in the county. Illustration from Frances Hurt's *Intimate History of the American Revolution in Pittsylvania County, Virginia*.

The Road to Yorktown

unsuccessful at defeating Washington's army or at gaining another victory in the northern colonies, decided to begin a second invasion of the southern colonies at Charleston.

Upon hearing of the distress caused by the British invasion of its southern neighbor, Virginia lent assistance. *Hening's Statutes* records that the Virginia General Assembly called for 2,500 men to aid the South Carolinians, designating the Pittsylvania County quota of 97 men. William Witcher, a veteran of the Indian Expedition against the Cherokees and prominent county leader, led a company at the Battle of Stono Ferry, twelve miles west of Charleston. William Nance of Pittsylvania was also there with Colonel Mason's regiment, as was Pittsylvania soldier Abraham Aaron Jr., son of this author's fifth great-grandfather. In 1780, Captain Adam Clement and his company of Pittsylvania men met other companies at the home of Peter Perkins on the Dan River, then marched to Hillsborough, North Carolina, then to South Carolina to support General Lincoln at Charleston.

The Siege of Charleston by the British eventually resulted in General Lincoln's surrender on May 12, 1780, of the entire American southern army of 5,500 troops. Afterward, the British under Lord Cornwallis fought another American army at Camden, South Carolina, on August 16, 1780. Avery Mustain of Pittsylvania County, who had previously served in Captain Thomas Dillard's company and also served in the Cherokee Expedition, fought in the Battle of Camden along with Captain Adam Clement and his company.

Frances Hurt, in *An Intimate History of the American Revolution in Pittsylvania County, Virginia*, provides a somewhat humorous but sad excerpt from the pension application of another Camden veteran, Pittsylvanian Joseph Hubbard:

> *When the British Army had formed they cheered, huzzahed for King George first and charged bayonet. The Virginia Militia immediately broke and fled and no doubt the North Carolina done the same…Of the four Virginia regiments which fled from the enemy four companies never collected and this applicant among them at New Garden near Guilford C.H. North Carolina, the balance he never knew what became of them, some he supposed ran clear home & some went on by home no doubt & hid in the mountains.*

After that battle, Major General Nathanael Greene took command of the remnant of the Camden survivors, depicting the condition of the men as "wretched beyond description," noting that many were sick, nearly naked,

diseased and hungry. They were a shadow of an army, without supplies, wagons and munitions, since nearly everything was lost at Camden.

In support of Greene's Southern Campaign was the military supply depot at Peytonsburg in Pittsylvania County, which became the central location for the collection of supplies from all surrounding counties. It was an ideal location since it was situated deep in the interior, making it inaccessible by the enemy. The small village harbored Nathaniel Terry's and John Wimbish's stores and hosted a school and more than one tavern. What put Peytonsburg on the map, however, was its assignment as a military post, after which it quickly bustled with men and myriad activities.

Blacksmith shops repaired guns and made horseshoes. Wooden canteens were turned out by the hundreds. Warehouses stored supplies gathered from around the district, which were hauled by wagon to the southern army. At one time, Quartermaster William McCraw sent out a caravan of forty wagons. Cattle, hogs and sheep were herded down the road toward their destinations.

Among the drivers taking wagons back and forth from the military post were Pittsylvanians Samuel Harris, the future Baptist evangelist, and Robert Ferguson, whose pension application mentions his previous service in the militia. Ferguson enlisted at Peytonsburg and "remained in the service of the United States engaged as a wagoner driving the public teams under the Command of the said Wm. McCraw until after the end of the war." Wagons traveled from farm to farm, gathering whatever supplies were available. Mrs. Frances Hurt, in her *Intimate History*, recounts that "John Redd, wagon conductor for William McCraw, collected 228 sheaves of oats from Patrick Henry who lived nearby in Halifax County."

Supplying Greene's army was critical to his success, especially in the beginning, when Greene divided his debilitated army. Upon arrival at Charlotte, Greene sent part of his army to Cheraw, South Carolina, to recuperate, and the rest—his Delaware and Maryland continentals—he sent westward with General Daniel Morgan to harass British outposts. That decision culminated in the Battle of Cowpens, which the Americans under Morgan won handily and acquired a large number of prisoners.

Greene's poorly clothed and hungry troops retreated before rapidly advancing British troops under General Cornwallis. As Greene retreated, General Stevens's Virginia Militia escorted the five hundred prisoners from the Battle of Cowpens to Virginia. In his pension application, Pittsylvanian David Wray mentions that he was "ordered to guard these prisoners." Stevens's Virginians marched them to Pittsylvania County Courthouse,

The Road to Yorktown

where he discharged his men and turned the prisoners over to others who escorted them northward.

The retreat turned into a race to the Dan River at Guilford Courthouse in Greensboro. With eighty miles to go in severe winter weather, Greene's army beat the superior British troops to the river. The ragtag Americans crossed on February 14, 1781, and were reinforced by militia from around the region, including Pittsylvania County.

The letters of Thomas Jefferson around the time that Greene crossed the Dan River are infused with requests for militia from Pittsylvania and surrounding counties to come to Greene's assistance. It was also during this time that twelve-year-old Daniel Coleman acted as an express rider sent by Nathaniel Terry, the post commandant at Peytonsburg, to deliver a dispatch from Lafayette to John Wilson, the Pittsylvania commandant, to order troops to aid General Greene in crossing the Dan River. Coleman went on to become a distinguished justice on the county court and represented the county in the General Assembly between 1803 and 1806.

Besides militia joining Greene, supplies were procured and impressed from county citizens. In Mrs. Clement's *History* is listed a summary of contributions to the war effort at the time Greene crossed the Dan, obtained from the records of the Court of Claims held in 1783 after the war:

> *1,285 bushels of corn and 220 barrels of corn; 12,842 pounds of bacon and eight hogs; 45,550 pounds of beef and 22 whole beeves; 101 sheep and much mutton; 382 bushels of oats, as well as many sheaves and stacks of oats; large quantities of fodder and straw; much meal, flour, wheat, brandy, cider and chickens. Horses to the number of 55 were taken and 63 guns. Wagons and teams were commanded for various periods of time…of these fifty-five were listed.*

Most of the provisions were gathered by wagons going from farm to farm, giving people receipts for what was taken and taking the supplies needed for the troops back to Peytonsburg. Feeding an army of several thousand men was no small task, and a lot of supplies would be needed to provision Greene's troops and the reinforcements who joined him back in North Carolina.

It was at this time, too, that Thomas Jefferson sat at his desk and wrote the largest landowner in Pittsylvania County, David Ross. His plantation near the confluence of the Staunton and Pigg Rivers, named Ross's Quarter, was part of 7,800 acres that he owned in Pittsylvania County, not including land in other counties. Ross operated an enormous business and industrial empire

in the state during the Revolution and saw great success in "scrounging supplies for Virginia troops" during the war. Jefferson, ever mindful of his contributions, appointed him commercial agent for the state, giving him wide authority.

Meanwhile, Greene's army, now better equipped and better manned, recrossed the Dan River in an attempt to reclaim the Carolinas from the British. Among those in Greene's reinforced army was Pittsylvania County resident James Fowkles, who wrote in his pension application that his Pittsylvania Militia company, along with three others (about two hundred men), crossed the river at Boyd's Ferry at today's South Boston and joined General Lawson's brigade in the main army of Greene. "We continued marching in various directions sometimes in the night other troops falling in with us until the 15th day of March we met with the British & c. under Lord Cornwallis and had a severe battle with them in the county of Guilford, N. Car."

Pittsylvanian John Neal, who had previously served in Captain John Donelson Jr.'s company in the expedition against the Indians, records in his pension application that in February 1781 he served in a company of militia commanded by Captain Isaac Clement. They crossed the Dan River at Boyd's Ferry and then later marched in a regiment commanded by Colonel Peter Perkins into North Carolina. He wrote, "They were regularly marching in different directions, sometimes in pursuit of the British, and sometimes retreating from them until they met with Cornwallis in the County of Guilford, North Carolina where a severe battle was fought."

The cat-and-mouse game with Cornwallis ended with the Battle of Guilford Court House. It was perhaps the bloodiest battle of the Revolution and also one of the most decisive, for it set the stage for the final act in the war for independence. Greene's army had been joined by militia from a collection of counties in Virginia. Pittsylvania County companies that had joined Greene in the Battle of Guilford Court House were those commanded by James Brewer, William Dix, Thomas Smith and Joseph Morton, with Colonel Peter Perkins commanding a regiment.

We don't know all the names from Pittsylvania that fought at Guilford, but it must have been as Mrs. Clement says in her *History*: "We may well know that every able-bodied man in the county who could possess a gun was present."

Pension records note some of the wounded. Captain William Dix's company of Pittsylvania Riflemen fought under Colonel Campbell at Guilford, where Dix's horse was shot out from under him. William Gauldin,

The Road to Yorktown

Dix's Ferry, behind Danville's airport, played a significant role in the Southern Campaign of the Revolutionary War. President George Washington also crossed the Dan River there on his tour of southern states in 1791.

who had also fought in several skirmishes after Greene recrossed the Dan, mentions the severe Battle of Guilford and says in his pension application, "I was shot through the Head, the Ball coming out at the end of my nose, which rendered me unable to perform my duty whatever." Other Pittsylvania soldiers were wounded as well: George Dodson was shot in the knee; both William Gauldin and Nathan Rowland were severely wounded, with Rowland permanently disabled.

Greene sent his and British wounded north to a main hospital established in Pittsylvania County. In doing so, the troops crossed at Dix's Ferry on the Dan River in Pittsylvania County, behind the present Danville Airport, and at other ferries upriver. Dix's Ferry had also figured significantly as a decoy crossing in an attempt to deceive Cornwallis as to Greene's true direction in the race to the Dan in February.

Greene's hospital was established at the home of Colonel Peter Perkins, and others were established nearby at the houses of his brothers Constant and Nicholas and also his neighbor William Harrison. Dr. Daniel Brown of New York headed up the hospital, which from the Court of Claims records for Pittsylvania County appeared to be a large operation.

Frances Hurt in her *Intimate History* mentions various sums paid to Perkins and others for supplies. Thomas Cary was paid for shoeing "43 horses belonging to officers and doctors of the General Hospital kept at Colonel Perkins' home." William Norton was paid for 21 days that he collected

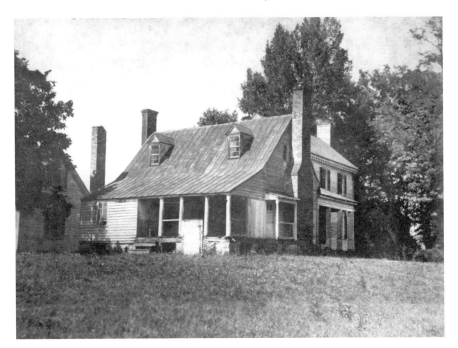

Berry Hill, once the home of Colonel Peter Perkins, stands near Route 58 west of Danville and served as a military hospital for General Nathanael Greene's American army during the Revolution. *Photo courtesy of Desmond Kendrick.*

and brought flour to the General Hospital. Peter Perkins himself supplied large quantities of food: 322 pounds of bacon, 1,128 pounds of pork, six sheep, 60 pounds of tallow and 12 pounds of beeswax. He was also paid for two wagons and teams for 102 days each and 105 pounds of bar iron, plus other expenses.

Colonel Perkins's home, still located on Berry Hill Road west of Danville, remained a hospital for three months. Afterward, the hospital was relocated to Charlotte, North Carolina. The hospital at Berry Hill was used for British and American soldiers, some of whom died there and were buried nearby. The name Berry Hill may have come from Bury-Hill, implying a graveyard. Many years afterward, the river flooded its banks and exposed relics from those graves associated with both armies.

Though Greene's army technically lost the battle at Guilford, it inflicted a mortal wound to the British cause. After Guilford, a broken Cornwallis retreated to Wilmington, while Greene refocused his attention on the South. Greene attacked British outposts in South Carolina, resulting in the Battles of Hobkirk's Hill and Eutaw Springs and the Siege of Ninety Six.

The Road to Yorktown

Captain James Turner's company of Pittsylvania Militia served at the Siege of Ninety Six. Daniel Bradley's pension application states that he fought at Guilford, Ninety Six and Eutaw Springs. Greene never won any one of these engagements, though he had limited success in other instances. However, he did inflict severe casualties on the British, and they retreated to Charleston, where they remained sequestered for the rest of the war.

After marching into Virginia from Wilmington, Cornwallis surrendered at Yorktown one month after Greene's battle at Eutaw Springs. According to *Virginia Militia in the Revolutionary War* by J.T. McAllister, several companies of Pittsylvania County Militia took part in the Siege of Yorktown, among them those commanded by Captains Charles Hutchings, William Dix and Charles Williams, all of whom witnessed the surrender ceremony in October 1781. The Court of Claims for Pittsylvania County also includes this item among others: "To Richard Todd for Riding Express to give militia officers notice and finding himself for four days in consequence of his Excellency the Governor's Order to order one quarter of the militia [of Pittsylvania County] to the Siege of York."

Among the other Pittsylvanians at Yorktown was Griffith Dickenson, who initially enlisted in the Continental army as a musician. He fought at Guilford also and lastly served as a commissary at Yorktown. Avery Mustain assisted in raising breastworks and batteries, and John Neal was engaged in constructing entrenchments during the siege. Both were detached to guard British prisoners surrendered at Yorktown to Noland's Ferry on the Potomac near Leesburg, Virginia.

Records show that Pittsylvania County was practically depleted of militia and supplies for the defense of Virginia after Cornwallis invaded and joined with the forces of British generals Philips and Benedict Arnold. The county's contributions, however, continued during the Siege at Yorktown and during the reclaiming of South Carolina by General Greene. Virginia called out three thousand more troops in 1782, and Peytonsburg also continued operations. Only the Peace of Paris in 1783 brought a complete end to conflict.

CHAPTER 7

ANTEBELLUM DAYS

The years between the American Revolution and the Civil War have been called Pittsylvania County's "Golden Years." Growth in population, industry, agricultural production, infrastructure such as turnpikes and railroads, better navigation of the rivers and culture in general prospered during that period. These were the plantation days, when tobacco was king and the county became a gateway to the western counties of Virginia.

Even before the Revolution ended, changes began to take place. Settlers in the county began moving westward. Colonel John Donelson and his family, including daughter Rachel, left for Tennessee in 1779. Rachel was twelve years old as her father led a flotilla of boats on a thousand-mile epic journey to locate near what is now Nashville. It was there that she met and married Andrew Jackson, destined to become the seventh president of the United States.

Despite some migration westward, the population of the county steadily increased as more and more people arrived in the area. In 1790, the first official census recorded 11,579 persons. By 1850, the number had increased to roughly 29,000 people, and prior to the Civil War, the number of inhabitants had tripled.

In 1782, just before the Revolutionary War was over, a courthouse was built near today's Chatham Town Hall, an act that eventually erupted into controversy. When the county was reduced to its present size in 1777, the county courthouse was designated to be located in the middle of a line drawn diagonally from the northeast to the southwest end of the county. However,

Antebellum Days

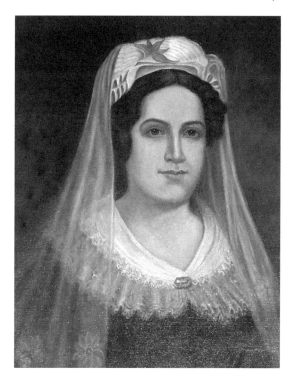

This portrait of Rachel Donelson Jackson, born in the family's home in the Markham community of Pittsylvania County in June 1767, hangs in the courthouse in Chatham. Rachel's father, John Donelson, led an expedition to Tennessee, where she later married Andrew Jackson, who became the seventh president of the United States.

plans to build a courthouse were postponed because of the Revolution, so the court met at the Cherrystone Meetinghouse, a location that offered the opportunity for ordinaries, taverns and various businesses needed for those traveling long distances to the courthouse and staying several days. Yet, when the courthouse was finally built, it was located "on the hill" to be more convenient and accessible.

Opposition erupted in 1806, and petitions with many signatures and affidavits attached were presented to the Virginia legislature by sides competing for business interests. In 1807, the legislature approved "the hill" location and ordered an eight-acre village be surveyed into lots—officially named Competition, due to the lively dispute. The village grew slowly, and for years to come the courthouse would be surrounded by mostly undeveloped farmland with few people.

The location of the first courthouse in 1767 was designated Chatham, but the name never took because the area became known as Callands instead. By 1852, the name Competition was changed by the legislature to Chatham, prompting the clerk of the House of Delegates, Henry St. George Tucker, to pen the words, "Immortal Pitt! How great thy fame, When Competition

A nineteenth-century map of Pittsylvania County showing Competition as the county seat before the name was changed to Chatham.

yields to Chatham's name." Despite the name change, Chatham in 1852 was still no more than a village, the same eight acres originally surveyed. It would be 1874 before the village would be incorporated into a town.

With the Peace of Paris in 1783, Pittsylvania County and Virginia's independence from Great Britain became official. In the ensuing years, the

Antebellum Days

adoption of a new constitution would occupy the states. On June 2, 1788, at Shockoe Hill in Richmond, 170 delegates met at the Virginia Ratification Convention. Nine states had already approved the document, but ten were needed to make it the law of the land.

Pittsylvania County sent two delegates: John Wilson from west of present-day Danville and Colonel Robert Williams, who lived near present-day Spring Garden. Both men held prominent positions in the county during the Revolution and both served in the Virginia legislature.

When the vote was taken, the Constitution was ratified 89 to 79. Both Pittsylvania County delegates voted "No!" No doubt they were influenced by opposition leader Patrick Henry, whom they knew well. Henry believed that the document presented lacked a declaration of individual rights and also allowed for an all-powerful central government that would oppress citizens such as Great Britain did the colonists. However, the county delegates' opposition probably played a vital role as Virginians then insisted on a Bill of Rights that afterward became part of the U.S. Constitution.

No sooner was the Constitution ratified than the first U.S. president, George Washington, toured the southern states in 1791. On his return trip, he crossed into Pittsylvania County at Dix's Ferry, located on the Dan River behind the Danville Airport, and spent the night in Peytonsburg. In his diary, Washington recorded, "June 4th left Mr. Gatewood's at half after six o'clock and between his house and the [Dix's] Ferry passed the line which divided the State of Virginia from North Carolina, and dining at one Wilson's sixteen miles from the Ferry, lodged at Halifax Old Town [Peytonsburg]."

Washington spent the night at the tavern and left the next morning before sunrise. His diary indicates that he continued through Pittsylvania County, crossing the Banister, and then stayed Sunday night with Colonel Isaac Coles, a former member of Congress, whose family became prominent in Pittsylvania County. Coles built a plantation near the Chalk Level community.

After Washington's second term as president of the United States, the John Adams administration that followed him succeeded in alienating Pittsylvania County citizens. Congress passed and Adams signed the Alien and Sedition Act, which allowed foreigners to be banished if they appeared to be a threat to the government and made it a crime to write or publish malicious or false statements about the president or members of Congress. The controversial issue reached the Pittsylvania County Court on July 15, 1799. Resolutions were introduced to object to the constitutionality of the law, and copies were sent to the governor and published around the commonwealth.

St. John's Episcopal Church, formerly St. Andrews, is located in the Mount Airy community and is the oldest continuous congregation in Pittsylvania County. Its roots go back to the Camden Parish of the Church of England, dating to the mid-eighteenth century.

During the years after the Revolution, the influence of the Church of England decreased dramatically, although the Episcopal Church continued with fewer adherents. Today several such churches exist in the county, including Emmanuel Episcopal Church in Chatham. St. John's Episcopal Church in Mount Airy, east of Gretna, is the oldest congregation in the county.

Even before the Revolution began, Baptist churches established their presence in the county. Famed Baptist evangelist Samuel Harris established several churches, including the earliest, named Dan River Baptist, organized in 1760 with his converts when he was still a layman. He also founded Country Line Baptist Church near Peytonsburg in 1771. The Upper Banister Primitive Baptist Church, situated along Route 29 South below Chatham overlooking the Banister River, was established in 1773, and Primitive Baptist congregations still flourish in the county.

A number of Baptist churches formed after the Revolution continued into the antebellum period and some continue even to this day. Among them

Antebellum Days

R.G. Rowland, pastor of Greenfield Baptist Church off Route 40 near Gretna, Virginia, points to the signature of Griffith Dickenson in the original church minutes. A Revolutionary War soldier, Dickenson organized the church in 1800.

are Kentuck Baptist, 1788; Shockoe Baptist, 1803; Mount Herman Baptist, 1811; Sandy Creek Baptist, 1824; Chatham Baptist, 1857; and Liberty Baptist, 1859, where Samuel Harris is buried.

Greenfield Baptist Church, originally known as Stinking River Meeting House, located east of Gretna, was established in 1800 by Griffith Dickenson, who served honorably in the Revolution. Original church minutes from the first meeting still exist. Greenfield, like many of these early Baptist churches, included white members and also black members, both freed and slave.

Baptist sentiment in the county made it a suitable place for the residence of John Weatherford, a staunch advocate of religious liberty in Virginia. Jailed in Chesterfield County in 1773 for preaching without a license from the Church of England, Weatherford preached through his jail cell window. When he gestured with his hands, they were slashed repeatedly with knives, leaving prominent scars. When a fence was built to obstruct the crowds who came to hear him, he would begin preaching to those he could not see when someone would raise a white cloth on a pole to alert him that an audience had gathered.

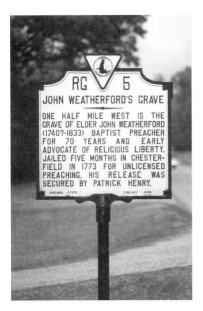

Baptist preacher John Weatherford, an early advocate for religious liberty in Virginia, spent his final years in Pittsylvania County and is buried near Shockoe Baptist Church.

Patrick Henry heard of his situation and paid his fines, allowing his release. In 1823, Weatherford moved to Pittsylvania County and became a member of Shockoe Baptist Church. He died ten years later and is buried near the church.

The first Presbyterian church in the county was named Wet Sleeve for a nearby stream. Samuel Calland took a prominent role in that church, which was organized in 1784. Today's Chatham Presbyterian Church was organized in 1886 on the site of the earlier one built in 1846.

Methodism also spread into the county during the Revolution. In 1776, Pittsylvania County was added to the Methodist circuit, and a church known as Watson Meetinghouse was established in the southern part of the county. Its name continues today through the Watson Memorial Methodist Church in Chatham.

Bishop Francis Asbury, the leader of the Methodist Church in America and the outstanding preacher of his time in American history, visited Pittsylvania County on several occasions. His first visit came on Sunday, August 13, 1780. His journal reads, "I rode to Watson's preaching house, a round log building…There were about 500 people. There was a moving. Mon 14th I preached at Colonel Wilson's to about 200 people." Asbury visited again in 1791 and also in 1799, each time speaking at the Watson Meetinghouse, and on his last visit mentioned crossing the Dan River at Perkins Ferry.

While the churches were making headway into country life, sinners still abounded and some found themselves headed for court. Records in the courthouse for April 1809–September 1821 reveal a plethora of recreational sins. Thomas H. Clark was charged with a breach of peace for assaulting Dr. C. Williams with his horsewhip inside the courthouse. Several were accused of playing cards in an unlawful manner at Richard Johnson's tavern or betting on a game at a place of public resort on the roadside.

Antebellum Days

View of Pittsylvania County Courthouse in 1940 along Main Street in Chatham with the Confederate memorial in the foreground. *Photo courtesy of Library of Congress.*

Major Richard Johnson was indicted "for retailing Rum and Brandy without a license" in the bar adjoining his storehouse in the town of Competition. In 1819, Henry Thomas was brought before the Pittsylvania County Court for "maliciously taking off part of George Bell's ear at Samuel Lovell's Tavern on the 19th April 1819." In September 1820, John Tucker and James George were present at court "for an affray of fighting by consent at the house of William Clark."

Besides being a place for records and punishment, the Pittsylvania County Courthouse of 1853 was an ornate building, illustrating Greek Revival architecture. That attention to design followed throughout the county as Greek, Gothic, Federal and other influences were incorporated into its homes. "It was not until the clouds of Revolution had passed," wrote Madeline Fitzgerald in *Pittsylvania Homes and People of the Past*, "and the courthouse settled at a more central place that the people of the county turned their thoughts to more elaborate homes, most of which took from five to ten years to complete. The bricks were usually burned on the plantation and the lumber well seasoned."

Characteristics of these plantation homes included hand-carved woodwork and wainscoting (wooden paneling that skirted the lower part of room walls), exquisitely designed mantels, graceful curving stairways and, on the outside, elegantly columned porticos, elaborate cornices and brick walls, all surrounded by entrancing gardens.

Pittsylvania County, Virginia

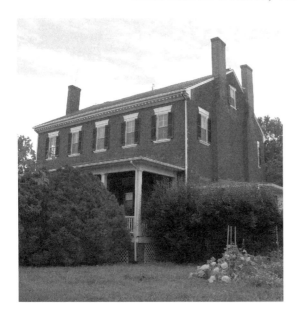

Belle Grove, built by William Tunstall in the 1790s, is located off Route 703 below Chatham. This example of Federal architecture is the largest brick structure in Pittsylvania County that remains from the 1700s.

Among the earlier homes, Belle Grove, built in the 1790s, became the residence of several generations of Tunstalls. Coles Hill—a Georgian-style home built in 1817 by Walter Coles I, the son of Colonel Isaac Coles—remains the family home of the present-generation Walter Coles. Dan's Hill on a knoll of the Dan River off 58 West was built in 1833 by Robert Wilson, the son of Colonel John Wilson. Eldon, later the home of Claude Swanson, built in 1830, and Oakland, built by Jesse Carter on Route 29 south of Chatham, like a score of others, serve as reminders of Pittsylvania's cultural heritage.

Many plantation homes were built near creeks or rivers and functioned as castles in the most basic sense—everything needed for the house and servants was produced within the confines of the surrounding property. Mills ground wheat and corn, and domestic animals such as pigs, cows and sheep provided food and, along with cotton, provided clothing.

Caring for the family amounted to more than food, clothing and shelter; the importance of education was also recognized. A plantation owner provided a schoolhouse in a cleared field for his children and often those from neighboring plantations. In 1801, private academies were established by the Virginia legislature, one being six miles from the courthouse on the Banister River. Others sprang up later at Whitmell, Callands, Museville and Cascade. In 1824, Samuel Miller, a Greek and Latin scholar, began the Woodbourne Classical School in the northern part of the county, which became one of the most popular schools in the region.

Antebellum Days

Hiring a private tutor or enrolling students in a private academy proved satisfactory for those who could afford it, but children of poor families were at a disadvantage. To remedy the problem, in 1810 the Virginia General Assembly ordered all lands and properties belonging to the Church of England be sold and the money to be used to establish a literary fund. Thus, in Virginia by 1818, a primary education was guaranteed to poor children.

In 1823, commissioners were appointed in each county to manage the fund, and those in Pittsylvania County reported in 1823 that 254 children were eligible for help. Out of this fund arose the state system of education. In 1829, Virginia chose its first state school superintendent, and in 1846 each county had a school superintendent. According to Maud Clement, by 1860 both public and private schools existed together in the county, including the town of Danville.

The beginnings of the Industrial Age in the county developed with the use of water power to run gristmills. These mills formed the earliest industry in Pittsylvania County, many being built in the colonial period and operating into the antebellum age when others were also built.

The very first gristmill belonged to William Atkinson at Harpen Creek as it enters Pigg River north of Climax. Built in 1747, Atkinson's Mill was followed by Benjamin Clement's Mill in 1748 at the confluence of the Staunton and Sycamore Creek. In 1759, Nicholas Perkins received approval to build a mill and ferry on Dan River near Oak Hill. Harmon Cook, one of the early colonizers of the county, owned two gristmills, one on Tomahawk Creek in 1770 and another one on Turkey Cock Creek in 1773 on land that he purchased from Thomas Jefferson's uncle, George Jefferson. John Pigg's Mill on Pudding Creek provided for the Dry Fork area.

The Banister River and its tributaries were especially great sites, with twelve creeks and Stinking River running into it. Before leaving the county, the Banister makes nineteen horseshoe bends, providing ample space for mills. Motley's Mill, the first and largest on the Banister, was built in 1785.

During the nineteenth century, the number of mills increased on creeks all over the county. With five rivers, fifty-four creeks, twelve forks of creeks and eight branches of creeks, mills popped up everywhere. Between 1767 and 1800, over 100 applications were made for construction, and by 1840 nearly 190 applications had been submitted to the county court.

Mills of the nineteenth century include one petitioned for in 1803 by Ralph Smith, son of John Smith of the Pocket Plantation on Sycamore Creek. The need for a gristmill on the plantation was due to the large

Cedar Forest Mill, located on Straightstone Creek near the Staunton River, is Pittsylvania County's only remaining gristmill capable of grinding corn and wheat using water power.

workforce. Stony Mill on Sandy River was built in 1824 and is still visible today off Route 863 west of Danville. Billy Johnson is a fourth-generation miller who owns a mill originally built in 1830 on Stinking River. A mill owned by Major Sutherlin of Danville on Double Creek developed into an industrial complex, with a coffin factory, carriage factory, sawmill and tobacco factory. Flippen's Mill on Birch Creek in 1850 became an important industrial site during the Civil War.

Mills were a driving force behind prosperity. Herman Melton concludes that they served as community centers, polling places, storehouses, commodity exchanges among farmers and retail outlets, while millponds became recreational sites. Sawmills many times adjoined the site, using the water power from the river or creek. The mills served as magnets for settlement, with stores and ordinaries built nearby, as well as churches and schools. The mills developed as settlement increased, but they also prompted settlement themselves.

Taverns were sometimes associated with mill settlements, and examples of taverns mentioned earlier and those here illustrate their importance in the community. Majors Beavers owned a tavern at Blairs, seven miles north of Danville, where in later years state legislator John Christian Blair allowed a school and railroad depot to be built on his land to serve the community.

Antebellum Days

Besides serving as a stagecoach stop, the tavern also served as the annual muster ground for the militia, where militiamen paraded around with little more than sticks and cornstalks for weapons. During the War of 1812, the county's militia strength consisted of the 42nd and 101st Regiments. A flag was designed for the 42nd Regiment of militia, commanded by Daniel Coleman to take on its deployment. It serves today as one of the few county flags in existence and hangs in the courthouse on Main Street in Chatham.

Another important stop was Yates Tavern outside of Gretna along old Route 29. Built in the mid-1700s, it was located on the Pigg River Road a few miles from Hickey's Road that led west. The Yates family acquired a license to operate an ordinary, the equivalent of a "frontier bed and breakfast."

With all the taverns, gristmills, schools and the needs of agriculture, improved ability to travel by water and land brought about other major changes in the county during the antebellum period. Roads, for instance, brought people, provided for increased trading, made traveling more convenient and, in general, improved the quality of life.

This Pittsylvania County flag originally designed on white silk was sewn for the Forty-second Pittsylvania Regiment, which served during the War of 1812. *Photo courtesy of Desmond Kendrick.*

Pittsylvania County, Virginia

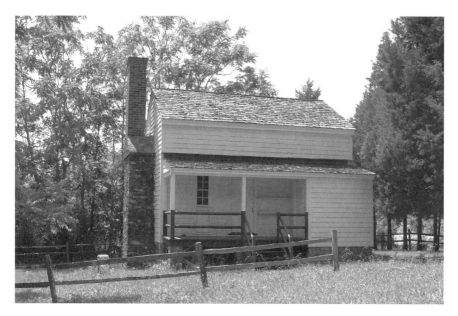

Yates Tavern, located off Route 29 a short distance south of Gretna, Virginia, was built in the mid-1700s and served as an ordinary, or frontier bed-and-breakfast, during colonial times.

In the antebellum period, at least two major roadways were established in the county, adding to the several roads already there. In 1824, citizens of the county petitioned the court for "the most eligible route for a road from the town of Danville to the Washington Iron Works in the county of Franklin." The Franklin Turnpike eventually stretched for ninety-three miles from Danville to Fincastle in Botetourt County. Along its route were tobacco factories, iron foundries, a shoe factory at the village of Chestnut Grove (later named Whitmell) and the communities of Swansonville and Callands. Today, Route 41 leading from Danville to Callands is a dual-lane, paved remnant of that once dirt thoroughfare.

In its day it functioned as a significant outlet for farm products. Maud Clement records:

> *It was known as the Franklin Turnpike and proved to be a great artery of trade, being the outlet to market for the mountain counties of Franklin, Grayson, Floyd and Carroll. Along its dusty way traveled droves of horses and hogs, herds of cattle and sheep, flocks of turkeys, wagon loads of chickens, apples and farm produce, seeking the market of Danville.*

Antebellum Days

Franklin Turnpike had six tollgates, one every fifteen miles, with the following fees: six cents for a score of hogs, twenty cents for a score of cattle, five cents for a horse or mule, fifteen cents for four-wheel riding carriages and twelve cents per animal for a cart or wagon.

In 1842, a turnpike from Danville to Lynchburg called the Stage Road provided travel between the two towns, the daily route between them being seventy-five miles. Beaver's Tavern outside of Danville served as one stagecoach stop. Relay stations existed at Chatham, Chalk Level, Grit and other places along the route. Located on the hill overlooking Stinking River on State Road 685, Brown's Tavern also became a stop where horses were changed and passengers might refresh themselves with food or drink. The stage, with four galloping horses, then headed for the crossing of the Staunton River at Ward's Bridge.

Ward's Tavern, built by John Ward around 1800, reportedly prepared meals for hungry passengers. When a stagecoach neared, the driver would blow his horn to signal the cook to start dinner—a single blast for each guest. Diane Popek, in her *Tracks Along the Staunton*, describes travel on the Stage Road as "rocky…holey…a paste of red mud in rainy weather and you could count on getting stuck at Sandy level and…White Oak Mountain."

In 1836, an ad in a Danville newspaper by Charles Calloway, proprietor of Bell Tavern near the courthouse, read, "All persons wishing to take a stage north or south are informed that the stage office is kept at the Bell Tavern, where every attention will be given to passengers." In addition to passengers, stagecoaches also carried mail.

Rivers were necessary routes of transportation since early times and Pittsylvania was no exception. The Dan and Banister flow into the Staunton or Roanoke River, which empties water from Pittsylvania County into Albemarle Sound in North Carolina. In 1804, the Roanoke Navigation Company was organized for improving the Roanoke River and its tributaries. By increasing the travel capacity of boats and bateaux on the rivers, trade was promoted between far-flung regions and provided relief from the overland hauling of products to Richmond and Petersburg. Hogsheads of tobacco and wheat flour along with produce reached markets by bateaux. A canal was built around the falls of the Dan at Danville, which allowed the boats to navigate around them.

By 1800, the steam engine had made its debut and the iron horse brought monumental changes in transporting farm produce and passengers. With the coming of the railroads, the use of water power went into decline, as

did the use of wagons drawn by horse or oxen for long-distance hauling. Transportation to eastern markets became much quicker from the western part of the state, and finished goods were better available to the western regions, including Pittsylvania County.

The leader in the effort to get Pittsylvania County its first railroad was Whitmell P. Tunstall of the Belle Grove plantation. Tunstall, a twenty-seven-year-old lawyer, represented the county in the legislature. In 1838, he argued for a bill to charter a railroad from Danville to Richmond. In his impassioned speech, he noted the opportunities for trade and marketing of products between widely separated areas of the state.

Due to the shortsighted opposition of special interest groups such as the Roanoke Navigation Company, Tunstall's effort would turn into a sixteen-year crusade. The Virginia legislature finally granted the charter on March 8, 1847, but it was 1856 before the last rails were set on this 140-mile track. A depot was located in Ringgold and its terminus in Danville. Tunstall did not live to see his great accomplishment completed, having died in 1854 of typhoid fever. With nineteen engines, the largest and most powerful named the Whitmell P. Tunstall, the railroad performed valuable service, especially for the Confederacy during the Civil War. Today, the Norfolk Southern Railway incorporates Tunstall's railroad.

By 1840, the Virginia census listed the county first in tobacco production, second in corn production and second in population. Prior to the Civil War, Pittsylvania County hosted tobacco warehouses and factories that manufactured chewing tobacco.

The county became a thriving community, with young professionals including doctors and lawyers making their ways from other areas of Virginia to a land of promise. Among them, George and John Gilmer came from Albemarle County, James Whittle from Mecklenburg County, Isaac Carrington from Halifax County, Dr. Edmund Withers from Campbell County and Dr. Benjamin Rives from Buckingham County. A small number of immigrants from Germany found their way to the county in the 1850s, namely Candidus Bilharz, Henry Viccellio and Matthias Bolantz. Others came from Switzerland, France and Bavaria.

By 1850, Chatham had three taverns and a hotel. Plantation homes were set in beautiful groves of oak and chestnut trees. Two racecourses were laid out, one on Belle Grove plantation, part of which is preserved as a straight stretch of Cherrystone Road in front of Chatham High School. Tunstall Paths was home to quarter horse racing. During Fourth of July celebrations of American Independence, citizens of the county gathered together at various places for patriotic speeches, feasts, dances and horse racing.

Antebellum Days

By 1850, the county was very much a part of the Industrial Revolution, as indicated by an inventory of industry first authorized by Congress for the Third Census in 1810. Herman Melton's research indicates that the county produced 18 bales of cotton and wove 179,606 yards of cotton goods on the county's 996 family looms that year, resulting, among other things, in over 13,000 pairs of stockings. Two hat factories produced 1,759 hats in 1810. Five tanneries processed 2,510 hides, which were made into 113,428 pairs of shoes, boots, slippers and saddles.

Industrial output in 1810 also included 750 pounds of gunpowder. Clement Hill, the county's source of gunpowder for the Revolution, continued to produce it during the antebellum period, and after Benjamin Clement's death, John L. Hurt produced it there for the Confederacy. The production of gunpowder may have been the very first manufacturing process carried out in Pittsylvania County.

Sixty legal distillers produced 76,283 gallons of spirits. "Dollarwise as far as production was concerned, this was Pittsylvania County's largest industry in 1810," notes Melton. Add to that the amount of illegal spirits that were likely produced and the total alcohol production is almost beyond comprehension.

By the Fourth Census in 1820, fifty blacksmith shops employed 119 people. In addition, there were tinsmiths, silversmiths and wheelwrights, but whiskey production again topped the list as the county's largest industrial production. By the Seventh Census, the county boasted an enormous increase in industry, with seven tanneries and forty-two tobacco factories as opposed to two factories in 1810. The Seventh Census also recorded shoemakers and saddlers in addition to the other professions previously listed. Of course, gristmills and sawmills continued to operate.

As mid-century neared, Pittsylvania Courthouse was surrounded by large plantations in a county with abundant business enterprises, several major roadways, bateaux plying the rivers, wagons and trains transporting products to market and railroads beginning to crisscross the county. The wilderness surveyed by the early explorers was disappearing, but the abundance of the land was being harvested.

Chapter 8

Tobacco Rows and Roads

Tobacco roots run deep in Pittsylvania County. When the first settlers arrived, they cleared the forest, built their cabins and planted their tobacco. From that time into the following centuries, tobacco has never had any serious competition as an agricultural crop.

It all started when Sir Walter Raleigh's expedition to the New World landed at Roanoke Island in what is now North Carolina. The Indians introduced these settlers to tobacco, which they took back to England. Colonel William Byrd, in his *Westover Manuscripts*, noted, "Amongst other Indian commodities, they brought over some of that bewitching vegetable, tobacco."

Even though the Indians introduced the colonists to it, a sweeter variety imported from the Caribbean by John Rolfe grew to become standard for the Virginia Colony. From then on, tobacco's importance captured the heart and soul of Virginians. Its economic impact on the state, including Pittsylvania County, has been phenomenal. *A Hornbook of Virginia History* spells out tobacco's importance:

> *Tobacco was the principal currency, and Virginians used it to purchase the necessities and the luxuries they imported from the mother country, to pay their local tithes and taxes, and to buy new lands on which to grow still more of the Indian weed.*

Tobacco Rows and Roads

Edward Pollock wrote in 1885 in his *Sketch Book of Danville, Virginia* that

> *the agricultural importance of a large section of Virginia, North Carolina and other states, the wealth of their citizens, and the establishment of many a floundering town within their borders—all these things, and more, are traceable directly to the discovery, two centuries ago, of a nauseating weed.*

Of course, it must not be forgotten that England as the mother country assumed that the British parliament had the right to regulate the economy of the Virginia Colony from top to bottom. The Navigation Acts of the seventeenth century required the American colonies to import and export products only from Great Britain. Tobacco could only be sold to British merchants and shipped on British vessels from British ports. British merchants increased in wealth as Virginia colonists bought from them furniture, clothes, kitchenware and myriad other products, adding to England's prosperity. Great Britain then resold tobacco to other countries.

The Virginia Colony, including Pittsylvania County, became dependant on tobacco because vast plots of land were available for cultivation, demand in England and Europe was high and it was without doubt the most valuable agricultural crop. In 1640, Virginia produced 1.3 million pounds of tobacco, but by 1755, the state exported 42 million pounds. Virginia prospered as the riches envisioned by the early explorers appeared in the form of the golden leaf. And the light-gray sandy soil so prevalent in Pittsylvania County was just right to produce enormous quantities of that sweet-scented bright-colored leaf.

That tobacco dominated the lives of all involved with it is an understatement. It was a time-consuming, manual labor–intensive enterprise. From *Old Dominion New Commonwealth*, we learn that on large plantations slaves did all the work, but on smaller farms the planter and his family with a few slaves worked side by side in the fields. Frederick Siegel says in the *Roots of Southern Distinctiveness* that only 6 percent of all farms in Pittsylvania County were one thousand acres or more. Most Pittsylvania tobacco farms were small by comparison, meaning that the farmer and his family likely worked as hard as the slaves.

Not only was tobacco manually demanding, but the crop also required more skill and knowledge than any other agricultural crop. As Siegel notes, "Tobacco, unlike the other plantation staples, was a delicate crop that required great care and attention at all stages of its growth and curing…On

Rows of tobacco plants, some waiting to have the blooms removed or *topped*, allowing the leaves to grow larger. A curing barn stands in the background.

the plantation heaven and earth is moved to solve any problem or difficulty with the tobacco plant." From the *Virginia Writer's Project* article "The Negro in Virginia," we find the comments of former slave Henrietta Percy. She remembered that if slaves cut a leaf before it was ripe they could "git a lashin." She furthered stated, "Us black people had to look after dot 'baccy lak it was gold…Marse ain't cared what we do in de wheat en' corn field… but you better not do nothin' to baccy leaves."

The reason that tobacco involved so much time and effort is because it took more than a year to produce—eighteen months from seed to sale. Once prized or packed into large barrels called hogsheads, weighing a thousand pounds or so, the tobacco could be transported to market. The tobacco would then be taken to a public warehouse, where it was inspected, weighed and stored by government officials. By 1730, inspection stations were built along Chesapeake rivers about twenty miles apart. By March, ships arrived to transfer the hogsheads to mercantile companies in England and Scotland.

Once in Britain, the tobacco was processed by purchasing agents who also served the planter by buying china, furniture, hats, shoes, cloth, paint and other sundry items for him. Later on, merchant businesses located near

inspection stations in the colony and would purchase the tobacco for the seller and handle the inspection procedures. Actual cash usually did not change hands because the merchant kept a list of ongoing debts and credits.

Small farms usually sold to larger farms instead of dealing directly with British merchants. By 1730, Scottish firms moved to places like Norfolk and Williamsburg and into the Piedmont settlements. They set up small stores, which traded tobacco for finished goods.

The difficult part for Pittsylvania farmers was getting the tobacco to the inspection stations along the James River. The distance measured 150 miles over rough roads, and a good part of the potential profit included paying for transportation. There were three ways to convey tobacco to inspection stations. First, it could be hauled in wagons—two hogsheads to a wagon weighing from 1,000 to 1,200 pounds each. The tobacco could be rolled in its own hogshead with a pole through the middle. Lying on its side and shafts fastened to each end of the pole, it could be pulled by horses. Once at the James River, the tobacco would be loaded onto long, narrow flatboats called bateaux.

Bateaux were canoelike boats approximately fifty feet long and lashed together side by side. A platform was laid across the boats with a carrying capacity of eight to ten hogsheads of tobacco. The boats floated downstream, and the three-man crews poled them back. For the bateaux ride, the tobacco from Pittsylvania County had to be first taken to Lynch's Ferry located at today's Lynchburg. This involved rolling the hogsheads or wagoning them there and then loading them onto bateaux. The boat trip to Richmond and back took ten days.

County surveyor John Donelson's map showing the dividing line between Halifax and Pittsylvania Counties (1767) has marked on it "the roaling road," also called Ward's Road. That road led to Ward's Ferry on the Staunton. From there the road continued to Lynch's Ferry. The map referred to the road where the horse-drawn casks were pulled to the James, where they were loaded on boats for the trip down river.

Life at the Pocket Plantation in northern Pittsylvania County paints a picture of those days. John Smith employed the services of Scottish merchant Alexander Stewart 150 miles away on the James River. Stewart's letters, excerpted in Maud Clement's writings, reflect a decade-long snapshot of tobacco plantations in Pittsylvania County and the vagaries of dealing with merchants far away from the county, depending on them for handling tobacco and supplies needed by the plantation. Stewart sold the tobacco for Smith, purchased cloth items of every kind, sought a local tailor for custom

fittings and even purchased a slave for the plantation. In January 1769, a letter reads, "The negro fellow Tom shall wait here for an opp'ty to be sent to you." If raising tobacco was a time-consuming job, Stewart's letters indicate that the time involved in transporting tobacco and in getting back household goods procured by the merchant and shipped in from England was time consuming also, especially if inclement weather was involved.

Up until the 1830s, most tobacco from the county was exported, but following the financial Panic of 1837 that swept the nation and brought a downturn in tobacco, only manufacturing facilities survived. By then, chewing tobacco had become popular in the form of plug and twist tobacco, and increased demand led to a doubling of manufactured tobacco in Pittsylvania County between 1840 and 1850. A tobacco factory was often associated with larger planters and became an integral part of the plantation system. According to Maud Clement, "In 1840 there were 20 factories in the southern part of Pittsylvania County, using 400 slaves. In 1850 there were 25 factories in the county."

By 1840, Pittsylvania produced more tobacco than any other county in Virginia—6,439,000 pounds. The success of Pittsylvania County tobacco, however, was due in large part to a new way of curing that developed about the same time. Around 1800, farmers tried fire to cure the tobacco, but the smoke left a bitter taste. Charcoal was tried to do away with the smoke, but the best advance came with the development of flues. Pipes extended inside the barn from an external fire box, releasing heat inside the barn and then expelling the smoke through an outside opening. The heat without the smoke developed a brighter leaf and improved the flavor. In 1829, Nat Robinson on his White Oak Mountain farm developed his own method of curing in this fashion. From then on, White Oak tobacco became the popular standard. The method has been hailed as one of the greatest developments in agriculture.

This Bright Leaf tobacco, as it became known, was lighter and delicate, golden and fragrant, with a sweet flavor. Pittsylvania County and those bordering counties in Virginia and North Carolina that produced it became known collectively as the Old Belt. The popularity of Bright Leaf tobacco created heavy demand in America and abroad and led to a tobacco boom in Pittsylvania lasting well into the twentieth century.

The influence of tobacco in the early days was more than economic. Just as roads were necessary to get tobacco to market, the growth of towns and population were also affected. Large landowners in the county had their plantations near rivers with rich bottomland that grew tobacco and

Tobacco Rows and Roads

Modern-day irrigation of a tobacco field with water from a nearby farm pond.

other crops well, and they became little communities in their own right. Consequently, the development of the tobacco plantation impeded the development of towns.

Sam Pannell, a Scotch-Irish settler, built Green Hill plantation on the north side of the Staunton River, but he also owned land on the south side in Pittsylvania County. Although a ferry had existed at the site, he built a wooden bridge using slave labor and opened up a road connection from Lynchburg to Halifax County. He owned and operated flatboats, which he used to ship products downriver. Green Hill had mills, shops, stores, a chapel, farm buildings and so forth. Siegel in *Southern Distinctiveness* likened it to a self-sustaining community, and this estate, like others of these tobacco plantation settlements, competed in attempts to establish towns. "Plantation villages on major thoroughfares were the only centers of trade until the emergence of Danville."

Siegel points us to another example where it appears that tobacco played an important role in establishing commerce and increasing trade. John Wilson, the son of Peter Wilson, a Scotch-Irish immigrant who settled in Pittsylvania in 1746, operated a store at the family ferry site on the Dan River off Route 58 west of Danville. By 1800, with his twenty-eight wagons and twenty horses, he was in the business of transporting cargoes around the rapids of the Dan River and north to Lynchburg. Likely much of that

cargo was tobacco, which was Wilson's chief interest as well. In 1795–96, his production alone amounted to around forty-four thousand pounds of the golden leaf.

Despite the slow growth of towns due to thriving tobacco plantations, tobacco nevertheless helped populate Pittsylvania County. Tidewater residents migrated to the county to acquire new land with more fertile soil, rather than the soil of the eastern part of Virginia, which had been exhausted by tobacco.

Without a doubt, tobacco made Pittsylvania County a prosperous and growing region, more so than any other crop or industry. It was instrumental in the rise of the county's first town, Danville, which became known worldwide as a Bright Leaf market. Pittsylvania County's tobacco fields were more than just rural farms; they were nurseries with national and international economic impacts rightly envisioned by the early traders and explorers such as Colonel Byrd, who believed in the bounty of this Eden.

CHAPTER 9

THE OTHER PITTSYLVANIANS

Pittsylvania is both black and white and has nearly always been so. And regardless of ancestral origins and the pain of the past, Pittsylvania citizens are connected, joined by a common history that began in 1619 when the first cargo of Africans arrived on America's shores.

The rise of Pittsylvania County from the red clay soil of the Piedmont was due primarily to tobacco, but the slaves who tended the tobacco made production and profit possible. While not all families owned slaves and some only a few, slavery was the order of the day during the colonial and antebellum period of the county's history.

Haunting reminders of slavery still exist in Pittsylvania County. Remains of slave dwellings and slave graveyards can be found, and structures such as the Richmond and Danville Railroad Bridge were built around 1854 entirely by slaves. Notable plantation houses that dot the county were doubtless largely built with the help of slaves. A significant number of the black population in the county descends from former slaves, with some of their surnames going back to the names of plantation owners.

With the advent of tobacco as a major crop and the importation of slaves to work the land, the slave population in Virginia escalated. Pittsylvania County's first census of tithables showed a white-to-black population of 3:1, but that did not include slave children under sixteen. The slave population increased seven times in the next fifteen years when Pittsylvania County became its present size. From 1790 to 1820, the slave population increased 300 percent, while the white population increased by only 48 percent. By mid-nineteenth century,

slaves were 46 percent of the population in Pittsylvania County. According to Karl Bridges's statistical study for his master's thesis, in 1850 approximately 52 percent of Pittsylvania households owned slaves but only 13 percent of households owned 20 or more slaves. Most slave owners held fewer than 10 slaves. Another source notes that in 1860, on the eve of the Civil War, 1,225 slave owners in Pittsylvania County owned 14,105 slaves.

If slavery was widespread, it was also acceptable. And the Holy Scriptures were offered as supporting evidence that possessing slaves was not only acceptable but also justified. On November 10, 1785, a petition was filed by some well-known citizens of Pittsylvania County to implore the General Assembly of Virginia to reject the crusade to take away slavery:

> *Gentlemen: When the British Parliament usurped a Right to dispose of our property without our Consent, we dissolved the Union with our Parent State, and established a Constitution and form of Government of our own, that our property might be secure in the future; in Order to effect this we risked our Lives and Fortunes, and waded through Seas of Blood. Divine Providence smiled on our Enterprize, & Crowned it with Success.*

The signers insisted that deluded men among them were attempting to dispossess them of a very important part of their property and offered biblical passages for their support. Leviticus 45:44–46 in the Old Testament speaks of buying men and maids, children and families for possessions and God's people passing them on to their own children as inheritance. The concluding biblical phrase reads, "They shall be your Bond men forever." The petition further stated that neither Jesus nor his apostles changed this.

Scripture was even cited to show that when someone embraced Christianity, their outward situation, if a slave, did not change. They quoted St. Paul from 1 Corinthians 7:20 ("Let every man abide in the same calling wherein he is called") to further condemn those trying to do away with slavery in the county.

The systemic effects of doing away with slavery came out in this poignant paragraph toward the end of the petition:

> *It is ruinous to the State. For it involves in it, and is productive of Want, Poverty, Distress and Ruin to the free citizens;—Neglect, Famine, & Death to the helpless black Infant and superannuated Parent; the Horrors of all the Rape, Murders, Roberies, and Outrages, which a vast Multitude of unprincipled, unpropertied, vindictive and Remorseless Banditti are capable*

The Other Pittsylvanians

of perpetuating;—inevitable Bankruptcy to the Revenue, & Consequently Breach of public Faith, & Loss of Credit with foreign nations;—and lastly, sure and final Ruin to this now free and flourishing Country.

In other words, the petition insisted that slavery was not only the cornerstone of the prosperity of Pittsylvania County but also of this country on a national and international scale; the signers of the petition imply that America as a nation would collapse without it. The men who put their names to this petition constituted a who's who list of Pittsylvania County citizens. Among them are listed the names Crispen Shelton, Haynes Morgan, Samuel Calland, T[homas] Tunstall, Vincent Shelton, William Ward and Peterfield Jefferson—to name a few.

For whatever reason, the Virginia legislature did not outlaw slavery, and slaves continued to be imported, bought, bred for children and sold at the whim of the master, who held life and death in his hands. Even though the importation of slaves was banned after 1808, in Pittsylvania County slavery and slave trading remained an active part of antebellum life. In 1837, an ex-slave, eighty-seven-year-old Lorenzo Ivy of Danville, Virginia (born in Pittsylvania County and moved to the city when he was about fifteen years old), was interviewed about slave life before the Civil War. His interview, published in part in *Piedmont Lineages*, covered various topics, but on slave trading he remarked:

Dey sold slaves heah an everywhere. I've seen droves of Negroes bought in head on foot goin' Souf to be sold. Each one have an old tow sack on his back wif everytin' he's got in it. Over de hills dey come in lines reachin' as far as you kin see. Dey walk in double lines chained together in twos. Dey walk 'em heah to de railroad an' ship 'em Souf lak cattle.

In *The Hairstons: An American Family in Black and White*, author Henry Wiencek mentions the business transactions of slave trader Philip Thomas of Pittsylvania County. Thomas's principal markets were Richmond, Virginia, and Montgomery, Alabama. In a letter, he enthusiastically notes the going price of slaves. He indicates that fourteen-year-old girls bring from $1,250 to $1,275, number one women $1,300 and number one men $1,500–$1,600. Also, he was instructed to buy boys not less than one hundred pounds. Thomas asks, "Write me immediately what sort you think best to buy." Then he follows with, "I have bought [for resale] two women [with] a child apiece and both in the family way again."

Virginia banks were heavily involved in the slave trade and received profits from fees charged for accepting checks on faraway banks. Wiencek includes this comment from Philip Thomas: "I think I have raised our reputation some in the Danville Bank. Sutherlin says as long as we let our exchanges pass through his bank we can get his money." Dealing with the Bank of Danville would allow them enough goodwill to also borrow money from that bank.

William T. Sutherlin, a native of Pittsylvania County reared on a farm near Danville at the confluence of Dan River and Sandy Creek, owned land and farms in the area. He became a prosperous tobacco entrepreneur in the county and in Danville, where he opened the second-largest tobacco factory in Virginia. Sutherlin founded and was first president of the Bank of Danville.

From *Life in Old Virginia* by James J. McDonald, it is evident that many slaves became closely identified with their owners' lives; in fact, owners never referred to their slaves by that term—only as servants or Negroes. They cut down the forest to clear land for tobacco and other crops or for logs to build a house, cleared roads through the woods and shared the ups and downs of the owners' early lives in the wilderness.

Their labor was almost endless, but some learned occupations. Maud Clement mentions that slaves trained as carpenters, shoemakers, wheelwrights, weavers, blacksmiths, etc. Whereas male and female slaves usually worked in the field, the female slaves especially were involved in domestic manufacture; cloth had to be woven, dyed, cut and sewn. Cooking and other domestic chores were largely left to female slaves as well.

Slaves could also be hired out. Lorenzo Ivy, an ex-slave previously mentioned who was born in Chatham, remembers that his father was a "lackey boy" around the big house of his owner, Judge George H. Gilmer. His father learned the trade of shoemaker, and the judge hired him out to different shoe shops and eventually let him hire himself out to "make his own barguns." This was actually a bargain for his father, who opened his own shop after the Civil War.

Regardless of any civility extended toward slaves, they were expected to do their masters' bidding. In *Old Dominion New Commonwealth*, we read, "Servants and slaves had to obey; severe punishment for insubordination was thought appropriate except in extreme cases of abuse by masters or mistresses." Treatment of slaves was more determined by tradition and custom or the whim of the master than by law. And masters could be mean.

In another segment of his interview about slavery, Lorenzo Ivy mentions that he came to Danville from Pittsylvania County after Lee's surrender

in April 1865. He spoke grave words about his mother's master, William Tunstall. "He was a mean man. Dere was only one good thing he ever did an' I don't reckon he 'tended to do dat." While that statement may be an exaggeration to make a point, Ivy possesses credibility as an educated man, having graduated from Hampton in 1875 in the same class as Booker T. Washington. Exaggeration or not, his remarks were certainly not flattering to one of the county's leading families.

Despite the punishments, freedom was cherished like a pot of gold at the end of the rainbow. Slaves sought refuge from the drudgery of bondage in various ways, despite the fact that some of those ways were against the law. Runaways often stayed in the forests in Pittsylvania County and were secretly taken care of by other slaves who stole away from the plantations at night. Henry Wiencek tells of slaves gathering at night in the forests for meetings, to dance or to hear their own preachers, who would compare their bondage and suffering to the children of Israel. This was very subversive, and due to the large slave population, fear of rebellion and insurrection was real.

To subvert any such notions, all white men had to participate as needed with a group of patrollers who roamed at night along roads, checking barns and forest getaways to find those slaves meeting illegally or a slave out on his own without his master's permission. They carried whips to inflict punishment and did so with impunity. In one instance, Wiencek mentions that these patrollers came upon a religious meeting in the county, beat as many slaves as they could and one patroller screamed, "You ain't got no time to serve God, we bought you to serve us."

As bad as slavery could be, in some instances Pittsylvania County citizens could be held accountable for how they treated slaves, even though slaves were considered chattel property in the same class as horses and houses. Crispin Shelton was fined by the court for "working Negroes on the Sabbath." The August 1767 Pittsylvania Court records state that "James Barton was taken and brought before this Court on suspicion of feloniously stealing two slaves."

In another instance, the church investigated a slave's death. Herman Melton, in his book *Thirty-Nine Lashes Well Laid On*, aptly describes the punishment of a Pittsylvania County slave lashed to a tree and whipped with a cat-o'-nine-tails until he was in shock and barely conscious. At the end of the ordeal, the prisoner was cut from the tree and dragged to the blacksmith shop, where an iron shackle was attached to his ankle and a belt around his waist securing a chain hooked to a log. Then he was sent out to the field to cut and thresh wheat.

William Walton, whose plantation on White Oak Creek bordered White Oak Mountain, owned Frederick. This slave had escaped and after eight days' freedom was captured. His punishment was severe since he had left during harvest time, when he was badly needed at the two-thousand-acre plantation. Walton probably had a significant slave population as Pittsylvania planters go and wanted to make an example of Frederick.

Although appalling by today's standards, Melton notes that Walton's actions were not in violation of any law. If a slave's execution was ordered by the court for a serious offense, his owner was compensated the fair market value, but if the owner executed the slave without the court's consent then he was not compensated for the slave's value. As Melton says, "The only restraints upon punitive actions of a master in disciplining a slave were his own innate conscience and his concept of what constituted Christian moral behavior."

Word spread of the incident with the slave Frederick and how afterward he fell down in the field, unable to continue working with the chains and shackles. The overseer testified that he became "Senseless and Speechless." Frederick later died, though his master evidently did not intend for that consequence.

Walton was a prominent county citizen who served as an officer in the county militia and twelve terms in the Virginia House of Delegates. He was also a member of Upper Banister Church, built on the hill where Route 29 crosses the Banister River several miles below Chatham. The church had been founded with the assistance of Samuel Harris, the well-known Baptist evangelist, himself a slave owner.

The church appointed a committee to investigate the case against Walton. Eventually, after testimony that Walton was going to free the slave from the chains but could not find a file and thus did not intend his death, church minutes recorded the following: "The said Walton acknowledged that he was sorry for having put the chain on his negro—Whereupon the Church excused him and held him in fellowship." Case closed.

The fact that slaves were members of Upper Banister Church along with Walton created a situation that no doubt obligated the church to conduct the investigation, even though it did nothing about it. Slaves were routinely accorded membership in white churches by virtue of receiving the Gospel message, although it did not change their slave status or the consequences of their actions.

Baptist congregations were especially accepting of slave members. In an article in *Piedmont Lineages* titled "Early African-Americans in Pittsylvania

Church Records," researcher Roger Dodson came across unpublished minutes of a county church. Sandy Creek Baptist Church, located in the Sutherlin community, was organized on September 4, 1824, with seventy people. Twenty-one others joined by "experience" after the service. The members included ten slaves—seven females and three males—and one free black man.

On August 7, 1825, Hanner Sawyers sought to join Sandy Creek after the black church she had attended had disbanded. She had no letter to show her conduct but was accepted by her statement of faith. The church also recognized the slave marriage of Nelson and Clara, although it was technically illegal and they did belong to two different slave owners. After the Civil War, black members of the church withdrew from Sandy Creek and started their own church, Mount Zion Baptist Church.

Shockoe Baptist Church, organized by John Jenkins in the late 1700s, recorded in its minutes, "Alba a negro woman, the property of John Irby, was received into the membership of the church by experience."

According to *The History of the Pittsylvania Baptist Association 1788–1963* by Charles Leek, in 1844 the twenty Baptist churches showed a total membership of 1,968: 381 white males, 762 white females and 825 Negroes. Black members were assigned speakers in the church house or outside on a platform in the shade, where slaves could be preached to in ways they could understand. In 1792, the association considered a Negro slave Simon "ordained of God to preach the Gospel."

In one instance, we find written in the minutes of the Pittsylvania County Baptist Association, "Brethren Samuel Fitzgerald, John Cobbs, Jr., and P.S. Hedgepeth were appointed a committee to inquire into the destitute condition of our slave population and report." In other minutes, dated August 27, 1849:

> *We recommend to our churches to so construct or remodel our places of worship, to enable our colored people to attend at the places of worship, with comfort and convenience…We recommend to our brethren who are owners of slaves to collect their slaves as often as convenient, and read and explain to them the word of God, and further, that when the family is called together for prayer, that the servants, so far as convenience will permit, be also called, and that the Scriptures be read and such explanations be made.*

Although slavery was pervasive, not everyone was uncaring like the hard-edged overseer, the slave trader or the violent master who mercilessly

punished his servants. But the Baptists found themselves in a dilemma regarding slavery. As Leek writes, "They were caught between their inherent desire for the full freedom of all men in Christ and the certainty of the disservice they would force upon Negroes turned loose as lambs amid preying wolves in a world for which they were unprepared."

One of the most tragic consequences of slavery was even more severe than physical punishment. Families were separated by slave trading and the death of the owner or for other reasons. In recalling his slavery days and his mother's master, William Tunstall, Lorenzo Ivy said: "So old Tunstall separated families right and lef. He took two of my aun's and lef dere husbands up heah an' he separated all tergether seven husbands an' wives. One 'oman had twelve chillun. Yessuh! Seperated dem all an' tuk 'em south wif him to Georgy an' Alabamy."

One of the most common ways that slaves were separated from one another was through the owner's last will and testament. One well-known Pittsylvanian, John Wilson, who lived at Dan's Hill near the ferry, acquired large tracts of land and slaves during his life. In his will, he left his wife, Mary, his land on the north side of the Dan River, his water gristmill on Sandy River, all his household furniture, farm implements and all the stock of all kinds on all his plantations and twenty-nine slaves. He left property also to his sons and daughters, as well as to slaves. To Robert, twenty-one slaves; to Nancy, seven; to Patsy, eighteen; to Mary, seven; to his three granddaughters—Maria, Mary and Phebe—one slave each. At the death of his wife, her slaves were to be given to some of the children. Altogether John Wilson willed to his family eighty-five slaves. From information in the will it can be concluded that he separated a slave woman, Queen, from her two daughters, Phillis and Hollaway; Phillis from her son John; and Stepney from his mother Gracy. On other occasions, he left mother and children together, perhaps because they were younger children.

Slaves were not only left to children of slave owners but typically were handed down from generation to generation. When Pittsylvania County was formed in 1767, Crispin Shelton owned more than three thousand acres. Census records show that he owned thirty-seven slaves in 1782, and when he died in 1794, his estate appraisal listed fifty-one slaves, which were divided among his children. Crispin had seven sons and three daughters and willed them about four slaves apiece. Five slaves were given to Vincent Shelton Sr., often referred to as Major Vincent, who became a prominent county figure. When he died in 1839, he owned twenty-four slaves, some of whom belonged to Crispin. Five of these slaves went to his son, Captain Vincent Shelton Jr.

The Other Pittsylvanians

Not all wills were matter-of-fact separations of slaves as chattel to the ownership of others. Maud Clement notes that in Virginia it was the custom that if one slave wanted to marry another, one master would sell to the other. Griffith Dickerson, in his will in 1842, decreed, "In disposing of my negroes I desire every feeling of humanity to be regarded in parting husband and wife, parent and child."

Other wills probated in Pittsylvania County actually freed slaves. That of preacher Samuel Harris, the great apostle of Virginia, freed 5 of 16 slaves; namely, Hannibal, Pompey, Old Bobb, Jenny and York. One notable example was the will of John Ward, son of Major John Ward, who owned "The Mansion" across the Staunton River in Campbell County and also possessed land and business interests in Pittsylvania County. The will was probated in Pittsylvania County on November 20, 1826, and is quite lengthy. As one would expect, he left his land and property to his family, even to his nephews—with one exception. He freed all of his slaves, a total of 136:

> *It is my will and desire that all of any slaves now living or which may be living at the time of my death be free and I do bequeath to each and everyone of them their freedom upon my death in as full and unlimited manner as the law of Virginia will admit of.*

He further stated that if they chose not to be free they could choose their own masters, ones who could take them at the value set by the executors of the will. To his favorite servant Davy and his sister Nancy he left $150 each, a $40 horse each and three cows plus orders to share equally three hundred acres of land. He also left $15 to all others over fifteen years old and some land to four old slaves. Ironically, he left his nephew, Robert A. Ward, nothing from his estate.

Although freeing slaves may have occurred more from sympathy than conviction of the evils of slavery, evidence is found in a county deed book that at least one resident, Nehemiah Norton, in 1785 freed eight slaves, "convinced of the iniquity of keeping negroes in slavish bondage."

Free blacks were not as abundant as slaves, but there were 637 of them noted in the court record book *Register of Free Negroes for 1807–1865* in Pittsylvania County. Free blacks, those either born free in the county or freed by their masters, had to register and be numbered at the clerk's office, a procedure that had to be approved by the court. Alva Griffith, who published a transcription of the court record, notes that freed slaves were to reregister every three years; when they did, their sex, age, height, complexion, facial

features and scars, etc., were recorded. John Ward's freed slaves were the largest number freed by a slave master in Pittsylvania and were also listed in the register and certified by the court.

From Griffith's research we also learn that in 1820 there were thirty-three white families in Pittsylvania County on whose property free blacks resided, and that number tripled by 1840. During that same time period, the number of free black heads of households in the county increased from three to seventy-eight. Thus, all through the antebellum period free blacks remained in the county and led productive lives. Records show also that slaves were freed up to the Civil War.

Of course, the vast majority of blacks in Pittsylvania County were not free but slaves, and the most prominent of all slave owners in the county was Samuel Hairston. The extent of Hairston family plantations and their slave populations is detailed in Henry Wiencek's Hairston family biography previously mentioned. "Samuel Hairston of Oak Hill," says Wiencek, "was probably the richest man in Virginia, and perhaps in the United States, the possessor of land and slaves worth $5,000,000. He was reputedly the largest slaveholder in the South."

Samuel Hairston of Pittsylvania County, according to *De Bow's Review*, a magazine published in the 1840s or 1850s that concerned agricultural and industrial progress, was one of the ten richest men in America, the only nonindustrialist in the group. He owned 1,600 to 1,700 slaves, but with the management of the slaves of his mother-in-law, Ruth Stovall Hairston, the number came to about 3,000. Sources say that, in all, the Hairston family slaves totaled 10,000 in five Virginia counties and four states. In fact, around 1850, Samuel Hairston, according to Wiencek's narrative, marched 700 slaves from Oak Hill in Pittsylvania County to Martinsville. They were a wedding gift for his daughter, Alcey, and her husband, Samuel Harden Hairston, who together founded Chatmoss plantation.

The Hairston plantation headquarters was Oak Hill, just off the Berry Hill Road that leads from 58 West to Eden, North Carolina. Giant trees still stand on the grounds there despite the overgrowth of the wooded areas nearby. The plantation home is just a shell, having been destroyed by fire some years ago. But nearby are slave quarters in a dilapidated state, as well as a carriage shelter and other estate remains.

On part of the old plantation is a slave graveyard covering several acres. Sunken graves in row after long row as far as the eye can see cover the hillside. The gravestones, mere rocks in most cases, are covered with a thick carpet of pine needles. A few jagged irregular rocks still stand at the grave heads

The Other Pittsylvanians

A young Ruth Stovall Hairston with her black child servant. Ruth Stovall's daughter married Samuel Hairston, who operated the largest slave plantation in Pittsylvania County at Oak Hill during the antebellum period of the nineteenth century. *Photo courtesy of Desmond Kendrick.*

of some. It would seem that the area contains hundreds if not thousands of graves, hidden in the forest, neglected by time and lost memories. A few graves are marked in a way that shows that black Hairstons were buried there well into the twentieth century. In contrast, down the road at the Berry Hill estate of Peter Perkins is located the ornate cemetery of the white Hairstons and other related families, marked by elaborate and engraved tombstones of exquisite beauty. Perkins, of course, had a military hospital for the men of Nathanael Greene's army after the Battle of Guilford Court House, where Perkins served as a colonel over a regiment.

The Perkins family had intermarried with other significant families of the area. Peter Perkins's father settled on Dan River in 1755. Peter married Agnes Wilson, daughter of Peter Wilson of Wilson's Ferry west of Danville. Their daughter, Elsie Perkins, married Peter Hairston, and they had a child named Ruth Stovall Hairston. She married her cousin, Major Peter Wilson

of Pittsylvania, and lived at Berry Hill. Their only child married Samuel Hairston, and they settled at Oak Hill. Berry Hill is the location of members of the white Hairston gravesites for that reason.

Descendants of the white Hairstons still live in Pittsylvania County, and a large number of descendants of the Hairston slaves reside in the county also, adding to the culture of the communities their talents and professions. If those slaves buried in unmarked graves near the old Hairston plantation could know what their descendants have accomplished in law, education, politics and business, they might realize that their skin-tearing lashes and their lost dignity was not for nothing.

Chapter 10

A Village on the Dan

Even though today the city of Danville is an independent city, a legal entity separate from Pittsylvania County, the two have always been part and parcel of one another socially, culturally and economically. For most of its existence, however, Danville was a community within Pittsylvania County. In fact, Pittsylvania County citizens initiated the legislation that created the town of Danville at the falls of the Dan River.

In the beginning, the river was the heartbeat of the town, its reason to be. In *A Brief History of Danville, Virginia 1728–1954*, Beatrice Hairston wrote, "The history of Danville is the history of its river. A river makes a town what it is; molds its life and the life of its people, the kind of work they do and the kind of pleasures they enjoy." For Danville, the first use of the river was as a crossing at the shallow ford that ultimately led to the founding of the little village.

Before ferries and bridges, shallow places in rivers that were usually far apart were the only way for horses, wagons and travelers to cross. The Main Street Bridge of today's Danville marks a shallow ford that was used extensively in colonial times. This ford on the Dan was near the falls, where water cascaded rapidly over a series of granite-hard rocks. The Indians first used the ford, and Danville's Main Street follows the old Indian path.

Maud Clement describes how the landscape at the river appealed to the Indians: "Low rolling hills by the side of a stately beautiful river form a situation designed by nature for man's abode. The Indians were quick to perceive the fitness of the location and put their towns there." Explorer

William Byrd on his second tour through the region in 1733 remarked in his *Westover Manuscripts* that the banks of the Dan were "a beautiful dwelling" and "happy will be the people destined for so wholesome a situation, where they may live to fullness of days…with much content and gaity of heart."

Five years later, William Wynne, a justice for Brunswick County when Pittsylvania was part of it, received a grant for acreage on the south side of the Dan River, "beginning at a branch below the old Indian Fort running up Rutledge's Creek." (This stream is now Pumpkin Creek, which runs through Schoolfield community to the river.)

Wynne later moved his family to the area in 1753, building his home near the falls, which eventually came to be called Wynne's Falls. It remained wilderness during the Revolutionary period, marked only by a path or trail leading from the south across the river and disappearing into the forest that rose 150 feet above the riverbank on the other side, where today's Main Street crosses the river. Slowly, other settlers made their way there.

Dr. George W. Dame, in his *Notes on the Origin of Danville*, quoted in Pollock's *Danville*, wrote:

> *Some years after the Revolutionary War, many of the gentlemen who had become impoverished by that War in the Eastern part of the State moved into this very thinly settled part of the country to begin life again. To keep up their acquaintances and talk over the past, they agreed to meet at Wynne's falls annually, at the fishing season, and enjoy themselves. The fish chiefly sought was the sturgeon, which then abounded in Dan River.*

Dame noted that they remained together several weeks, living in tents and supplying their own provisions.

In time, John Barnett, who owned land on the south side of the river, put in a ferry and later placed bateaux on the river for trading purposes. The increased trade prompted further development. The tradition is that the first building was a blacksmith shop, which eventually included a tavern and a store. Horses had to be shod before crossing the river, and at the ordinary travelers could await the subsiding of a river swollen from rain or just refresh themselves on their journey.

In 1793, a mere decade after the Revolution, fifteen prominent Pittsylvania County citizens petitioned the state legislature for a town "on the south side of Dan River, adjoining Wynne's Falls." They argued that "the situation of the place is suitably calculated for a Town, which will make the convenience of inspection more Serviseable." Among the petitioners were well-known

county planters including John Wilson, Peter Perkins and George Sutherlin, future father of W.T. Sutherlin, who became Danville's most prominent citizen of the next century.

A month after the petition in November 1793, the legislature granted "that 25 acres of land, the property of John Barnett adjoining Wynne's Falls, on the southside of Dan River, in Pittsylvania County…to be…laid off into lots of half acre each, with convenient streets and established a town by the name of Danville."

A tobacco inspection station was the real instigation for the town, since farmers had to transport their tobacco to Richmond or Petersburg for state inspectors to examine it. The tobacco warehouse was erected right away, and from September 1795 to September 1796 the warehouse received 249 hogsheads (about one thousand pounds each), with John Wilson shipping 44 hogsheads, the largest amount.

A post office was also established in 1800, and in 1801 a flour inspection warehouse was approved by the legislature, as well as a toll bridge crossing the Dan. The bridge made crossing easier and more attractive to travelers, except those who still crossed at the ford nearby to avoid the toll. By 1806, the Roanoke Navigation Company was organized to clear and deepen the Dan. Connecting rivers of the Roanoke River system made for easier transportation of goods to market.

In 1816, General Benjamin W. Cabell, who was born the same year as Danville, moved to the area and built his home on the river about a mile above the village. He and William F. Lewis erected a large flour, corn and oil mill near the toll bridge. Cabell also worked with the Roanoke Navigation Company to build a rock canal around the falls to allow bateaux to negotiate that stretch of the river and also to provide water power for the town.

In the 1820s, the wilderness that Colonel Byrd had seen one hundred years previous had fifty-nine structures along Main Street, including one newspaper, the Danville Male Academy and other schools, a tavern, a hotel and a Masonic Hall. Thompson Coleman, who would later become Danville postmaster and an alderman for twenty-three years, wrote about his arrival in the town in 1829. He described it as "a mere straggling village" that he entered by a road that led to Pittsylvania Courthouse. "The road was a common country road, unimproved by grading or otherwise, narrow and often impassable in winter because of sticky red mud, into which vehicles sank to the hubs." Coleman described the area on the north side of the river, which later became North Danville, as "a natural forest of primeval growth, unbroken by any house, settlement or clearing."

The road he traveled on led down the red clay hill to the wooden bridge across the river, which he indicated was only wide enough for one vehicle at a time. On the other side of the bridge was a three-story flour mill, a sawmill, corn mill and a building that housed a linseed oil mill, cotton gin and wool-carding machine. These were all run by water power from the canal. The road beyond the bridge forked, with one branch going south to Caswell County, known as the Hillsborough Road (today's South Main Street), and the other, known as the Salisbury Road (today's West Main Street), proceeding westward.

Houses and businesses, some two and three stories, formed a line of buildings up Main Street. Coleman mentions a tavern, a hatter's shop, a store, a tailor's shop, a lumber house, a silversmith shop, a tin- and coppersmith shop, a branch office of Farmer's Bank of Virginia, a shoemaker's shop, a tobacco factory and warehouse and the newspaper office of the *Telegraph*.

"The tobacco trade was in its infancy," commented Coleman. "It amounted to three hundred and fifty hogsheads per annum." Tobacco was sold prized, meaning pressed into hogsheads, inspected by state inspectors, who then issued a receipt, which the buyer used to purchase from the grower sight unseen.

Danville during the 1820s was primed for a period of prosperity. Increased trade from dredging the rivers, building bridges and canals and securing the state inspection site for tobacco duly increased population, resulting in more tobacco factories opening, as well as other businesses. In 1828, an industry destined to compete with tobacco as the area's greatest commodity began. The Danville Manufacturing Company was the village's first cotton mill, precursor to the largest single-unit textile mill in the world, Dan River Mills.

In 1833, the village of Danville was incorporated as a town and James Lanier, its first mayor, served with aldermen, a common council and other officials. The first ordinances, mentioned in Jane Hagan's *The Story of Danville*, limited tax to 5 percent of the value of property or rent. It was unlawful to throw dirt or wood on a street or walkway, have cow pens or pigsties on the front part of lots, throw sticks, stones or snowballs or build a fire in the street without approval. The police consisted of a citizen patrol, which was a compulsory service.

The town continued to grow to the point that prosperity offered time for leisurely pursuits even though the population was less than five hundred. A June 4, 1835 newspaper article mentioned "The Annual Fall Races over the Danville Race Course." Entrance fees were listed for these colt sweepstakes that lasted five days.

A Village on the Dan

Despite the era of prosperity, the town's economy stagnated as the financial Panic of 1837 spread across the nation. Its four tobacco warehouses closed and tobacco state inspection ceased. Other businesses also closed. For the next twenty years, Danville suffered through economic depression—would-be settlers went elsewhere, property prices plummeted and the once busy river traffic slowed considerably. Yet, Danville and the rest of Pittsylvania County rose from the ashes.

But not before other major catastrophes occurred. In 1847, a great fire destroyed most of the commercial section of the town and on Sunday afternoon, August 15, 1850, after an especially violent storm, a flood washed away the toll bridge across the river. Though primitive by today's standards, the bridge was an important link in the chain of commerce, as this legislative petition observes:

> *The road which passes through the counties of Halifax and Pittsylvania to Danville, and from there through the state of North Carolina, is one of the most public in the United States, being the Principal Highway of Travellers from the south and southwest to Richmond, the city of Washington, Baltimore, Philadelphia, and other large commercial towns of the north and east.*

W.T. Sutherlin came to the rescue and, in cooperation with other businessmen, built a wood covered bridge that lasted most of the nineteenth century. That bridge was the predecessor of the Main Street Bridge, now the double-span Martin Luther King Bridge.

By 1850, the population of Danville reached two thousand, but in the area known as North Danville only four houses existed. Much of the land belonged to the Claiborne and Worsham families. Also, the north bank of the Dan River boasted a flour mill, which had existed since 1831.

By 1854, the following streets had been laid out: Patton, Ridge, Craghead, Wilson, Loyal and Lynn. Within a few years the town extended as far up as present-day Holbrook Street. The weekly *Register* began publishing, and in 1859, Averett was established downtown from its predecessor, Roanoke Female Institute, the latter having evolved from the Baptist Female Seminary years before.

Danville coroner Jacob Davis, originally from Halifax County, moved to Danville in 1854. He kept a notebook of events that happened in Danville from 1855 to 1875. His notes for 1854 describe another catastrophic fire that caused severe losses in the downtown area. "At 10 1/2 p.m. a destructive

A view of Danville's lower Main Street from Edward Pollock's 1885 *Sketch Book of Danville, Virginia*.

fire burning all between Craghead Street and the Toll Bridge, both sides of Main St. Southside." A number of businesses were destroyed, and his list shows not only the extent of the tragedy but also offers an indication of the growth of Danville since the lone blacksmith shop was located at the ford of the river. Businesses destroyed by fire were several dry goods and grocery stores, an apothecary store, a barbershop, butcher shop, several lumber houses, a boardinghouse, a hotel and a confectionary shop, and W.T. Sutherlin's tobacco factory lost hydraulic presses and fixtures.

Serious as these were, none of the tragedies of the 1840s and 1850s destroyed the town's morale or will to survive. The town of Danville went on to become more prosperous than before. In 1856, the Danville and Richmond Railroad, inspired by Whitmell Tunstall, connected Danville to eastern markets just as the Franklin Turnpike that opened in 1842 connected Danville to the western sections of the state.

In 1856, W.T. Sutherlin built the second-largest tobacco factory in the state at the corner of Lynn and Loyal Streets. It was used as a prison in the Civil War and still stands today. He built the "Sutherlin Mansion," embodied today as the Danville Museum of Fine Arts and History. His leadership as mayor and then quartermaster during the Civil War marked times of prosperity and transition for Danville.

A Village on the Dan

Tobacco was the real success story of Danville during the late antebellum period. Despite the Panic of 1837, by 1850 Danville had become "the most important manufacturing center in the Dan River Valley," its factories producing plug and twist tobacco. Seven tobacco factories existed, with an annual purchase of approximately 2.5 million pounds. By the eve of the Civil War, six more factories operated.

The year 1858 was perhaps the most significant for tobacco in Danville because Thomas Neal built a warehouse that developed the "Danville System." After warehouses closed due to the financial panic, for the next decade or so growers brought their tobacco to town and piled it along the streets. By 1850, all tobacco was sold this way to buyers. Neal's warehouse brought the activity inside. Tobacco was arrayed in graded piles on the warehouse floor, allowing buyers to examine the loose leaves as they followed the auctioneer along.

Thus began Danville's rise to fame as the "World's Best Tobacco Market." By the mid-nineteenth century, Danville's textile and tobacco industries were set to blossom, and in the twentieth century these two industries would have a lasting effect on the town and county.

Chapter 11

The Civil War

After Abraham Lincoln was elected president in 1860, South Carolina, along with six other Southern states, seceded from the Union. On April 4, 1861, Virginia held a convention and voted in opposition to secession eighty-five to forty-nine. However, tensions escalated after April 12, when the Union garrison at Fort Sumter, South Carolina, took fire from secessionist forces. When news came across the telegraph that Fort Sumter had been shelled, the "streets of Danville rang with applause" and a Confederate flag was hoisted over the Methodist Female College on Ridge Street.

Lincoln called upon all remaining states of the Union to recruit seventy-five thousand troops to quell the insurrection; Virginia's part would be eight thousand. But Lincoln's request fell on deaf ears. Governor John Letcher of Virginia refused to send Virginia troops to fight fellow Southerners. Thereafter, Virginia's initial opposition to secession quickly withered. The Virginia Secession Convention met again on April 17, reversing the previous vote with eighty-eight to fifty-five in favor of seceding from the Union.

William T. Sutherlin of Danville and William M. Tredway of Chatham voted with the majority both times. Pittsylvania County citizens voted 6:1 to support Virginia's Ordinance of Secession, which effectively repealed the Constitution of the United States. Civil War was inevitable.

Enthusiasm for the war ran high in Pittsylvania County and Danville. Over the next few months, infantry, cavalry and artillery companies were organized across the county and in Danville. *Danville in the Civil War*, by Lawrence McFall, reveals that John Brown's raid in 1859 prompted the

The Civil War

organization of the Danville Blues and the Danville Grays. McFall relates that the Blues and Grays, along with the Spring Garden Blues from Pittsylvania County, marched together in the Eighteenth Virginia Infantry Regiment. The Pigg River Invincibles served as the lone county company in the Forty-sixth Infantry. Most county soldiers served in the Fifty-third, Fifty-seventh, Twenty-first and Thirty-eighth Virginia Infantry Regiments.

After secession, Governor Letcher ordered all Southside companies to proceed to Richmond on April 23, 1861. The message came over the telegraph at 1:00 a.m., and by 5:00 a.m. the Danville Blues and Grays were aboard railroad cars. "Thus went forth from our midst, on this mission of patriotism, more than two hundred of the flower of our young men," recorded the *Danville Register*.

The unit was ordered to Manassas to protect the railroads. In the ensuing Battle of First Manassas, there were a few casualties, but regimental chaplain Robert L. Dabney said, "All the streams and springs were contaminated from the putrfying bodies of men and horses, and soon nearly half of our men were in the hospitals and many died." The fate that befell many in the Eighteenth Virginia was typical of other regiments of soldiers—more died from diseases like typhoid and smallpox than from battle.

Regardless of losses from battle, exposure, heat and disease, the Eighteenth persevered, participating in other battles, including Antietam, where the creeks ran red with blood—the single bloodiest day of the Civil War with twenty-three thousand casualties. The end of the day left only forty-four men remaining in the Eighteenth's ten companies.

One of the first companies to form in the county was the Chatham Greys, led by Captain Rawley White Martin, a Chatham physician. This company was organized in March 1861 and later assigned to the Fifty-third Virginia Infantry Regiment. In the June 1967 bicentennial issue of the county newspaper, a *Star Tribune* headline read "Chatham Greys Left In High Spirits to Lick the Yankees." Quoting Captain William Tredway, the paper wrote, "The mail which brought marching orders for the Chatham Greys created no little sensation in the quiet and peaceful village and the news was soon heralded throughout the community." In contrast, Tredway also noted:

> *The 24th of April, 1861, was a sad day in Chatham. Many parted that day never to meet again on earth. Loving wives and children kissed husbands, parent and brother the sad goodbye; friendly hands gave a parting grasp to the soldier in the line…and escorted by Captain Cabell Flournoy's*

A five-dollar banknote from the Bank of Pittsylvania printed in May 1861 at the beginning of the Civil War. *Photo courtesy of Desmond Kendrick.*

> *cavalry company, amid the tears, huzzas, the waving of handkerchiefs and kissing of hands started off with banner flying and music playing and took up the march for Danville enroute to Richmond.*

All along the route excited crowds greeted them, which bolstered their spirits and determination.

When the Chatham Greys marched into Richmond, most had never been that far from home before. They were startled by "tall steeples, fancy windows, magnificent mansions and strange crowds." But the band struck "Dixie" and the men marched onward. They drilled, served picket duty and talked about when their first big battle would be and how they were going to win the war. "It was generally understood among us that if the Greys got a chance, and we feared we would not, the Yankee army would be literally cleaned out and that we would be occupied only a brief season."

Their opportunity appeared soon enough. The unit participated in what many consider the first land battle of the Civil War at Big Bethel. Though clearly outnumbered, the Rebels won handily. Private James Carter Jr. of Chatham, the father of historian Maud Clement, wrote of the regiment's return to Richmond with the first Yankee prisoners of the war. "The whole city greeted us with acclaim and it was with difficulty that we made our way through the enthusiastic crowds that thronged the streets." The Fifty-third Infantry served with the Army of Northern Virginia during the war from the first battle to the last, an honor few regiments attained.

Several Pittsylvania companies made up the Fifty-seventh Virginia Infantry: Company D, the Galveston Tigers; Company E, the Pigg River

Greys; Company F, the Halifax and Pittsylvania Rifles; Company G, the Ladies Guard; and Company I, the Pittsylvania Life Guards.

The Fifty-seventh fought throughout Virginia, but by the end of the war, from Charles Sublett's *57th Virginia Infantry* history come these staggering statistics for the war years: 71 were killed in action, 266 wounded, 429 taken prisoner, 173 died from various diseases common to soldiers of the day, 41 died from wounds in battle, 143 died from unknown causes, 158 deserted and 40 either retired or resigned during the course of the war. The Fifty-seventh's commanding officer, Colonel Clement R. Fontaine, proffered praise for his regiment. "For devotion to a just and righteous cause, no regiment…is more deserving of commendation. No set of men…underwent more hardships, or endured more for their country."

During the travels of the Fifty-seventh Virginia, a Pittsylvania County soldier whose family lived on Tomahawk Creek, Fourth Sergeant James Anderson of Company E, the Pigg River Greys, kept a journal. In it he mentions places and events around Richmond during May–June 1864.

In the Battle of Drewry's Bluff, Anderson's regiment went to the battlefield just before daylight on May 16, 1864, and when about three-fourths of a mile from the enemy, they charged through "a desperate swamp. Mud and water and no chance to keep a line." Close to reaching the Union breastworks, "the fire was so desperate that we could not withstand them very long…We fell back and formed with a loss very heavy in wounded." Anderson described the battle as "some of the hardest musket fighting I ever saw." Before it was over, Private James Anderson was wounded and sent to Chimborazo Hospital in Richmond and then to Danville's Confederate hospital. Anderson said:

> *There I got to go home about two weeks, and a finer time I never saw before. So I thought my wound soon got well. I do not think that the ladies saw but little piece while I staid. I believe that if I had staid there with them a little while longer that I would not have cared to have come back atal to have seen the boys in a good while, as good as I liked them.*

Anderson's journal also tells of the intense fighting at Petersburg and confrontations with the "Yankes." Then he tells about a box sent from home, reminding us that, despite the agonies of war, humor was never far away.

> *It had several very good things…in it, but, of all, the bottles of brandy that was in it suited me. It would have done any fellow good to have seen me sit*

and ease back and drink it. It was so good that I would not have cared if my neck had have been as long as the Richmond and Danville Railroad and it had have had to run all the way down slow at that.

Anderson might be amused to learn that the gristmill he later built (known then as Anderson's Mill) near his family's homeplace after the war, now named Tomahawk Mill, no longer grinds meal but produces wine from its own vineyards.

Another humorous moment in the war occurred when Captain Isaac Cole's company of the Sixth Virginia Cavalry had been sent on a scouting mission and encountered some Yankees, before whom they beat a retreat to their own lines. Confederate pickets halted them as they rode in and heard them call out "Pittsylvania Cavalry." The pickets thought they said "Pennsylvania Cavalry" and raised their guns to shoot. Then one of the company hollered, "Don't shoot, don't shoot. It's us. It's us!" Thereafter Cole's company always referred to themselves as "Virginia Cavalry."

The Thirty-eighth Virginia Infantry Regiment was referred to as the Pittsylvania Regiment since seven of the ten companies in the regiment were from Pittsylvania County: a Kentuck company; the Pittsylvania Vindicators; the Laurel Grove Riflemen; the Whitmell Guards; the Cabell Guards (mostly from Danville); the Secession Guards; and the Cascade Rifles. They, like the other regiments, engaged in the battles of the Army of Northern Virginia.

In *Piedmont Lineages* is found a letter from a Confederate soldier of the Thirty-eighth from Pittsylvania County. Thomas J. Hines wrote home to his wife Nancy from camp at Chickahominy Ferry in April 1862, relating circumstances around the Battle of Williamsburg:

The fight lasted ten hours in heavy firing. We made a charge on a battery and the balls fell as thick as hail. We killed a great deal of them and took 700 prisoners and nine pieces of artillery, and a good many arms. We left all the dead on the field to fall back near Richmond. We have been marching eight days without anything to eat except parched corn and that very coarse—an ear to each man. That is hard living.

The hard living intensified his fond memories of home all the more:

Oh, if I could take one good meal of victuals with you. I think it would do me the most good of all the things in this world if I could have some of your good buttermilk and cornbread...I am in hopes that I will be spared

The Civil War

to see you and my three little children, who feel so dear and near to me…I am in hopes I will have the pleasure of seeing you and them once more to ease me from my trouble and great sorrows of my heart. I am in hopes that we will meet ne'er to part.

He signed the letter "Your most dearest husband until death, Thomas Hines." Thomas was wounded three weeks after writing this letter at the Battle of Seven Pines. He recuperated in the Danville hospital, rejoined his unit, was present at Lee's surrender and then returned home to his wife and children. He died in 1912 and is buried off Mount Cross Road in Pittsylvania County.

Private Henry Clay Allen enlisted with the Thirty-eighth Virginia and later recalled how anxious he was to get into the war and how eager to get out. He wrote, "Being afraid that the war would be over before I arrived at the required age, I volunteered eight months before. Really got satisfactory experience before I was 19 and would like to have returned home and tried to get out but failed." Allen was wounded near Petersburg in 1864 and "was in much hard marching and much shooting. I'm not absolutely sure I killed a Yankee, but killed as many of them as they did of me." After the war, Allen became a member of the Pittsylvania County Board of Supervisors and a member of the state legislature.

The Chalk Level Grays, under Captain Sherwood Mustain, and the Turkey Cock Grays, commanded by Captain William Witcher, the son of Vincent Witcher of Pittsylvania County, served in the Twenty-first Regiment. The regiment fought extensively with Stonewall Jackson in the Valley Campaign of 1862.

While Pittsylvania companies fought together in some of the same battles, it was at Gettysburg that they experienced the turning point in the war and marched themselves into glory. The Battle of Gettysburg, the high-water mark of the Confederacy, July 1–3, 1863, reached the height of intensity the last day. The Eighteenth, Thirty-eighth, Fifty-third and Fifty-seventh Regiments marched in that long gray line that attacked the Union stronghold on Cemetery Ridge, a battle forever known as Pickett's Charge. It was a disaster.

It all started over shoes. Procuring shoes for the Confederates was always a serious problem, and stories tell of soldiers marching through winter weather barefoot in the cold. The previous year, in April 1862, Robert Barrow of the Danville Grays described the Eighteenth Regiment's march for Richmond. "My feet were so blistered that I could hardly put one foot before the other [and] I heard one of the boys say he saw blood running out of a man's shoes

his feet were so bruised." Going hungry was bad enough but hard marching wore out shoes, and without shoes, marching was a hellish experience. And they marched aplenty.

At Gettysburg, Pennsylvania, a Confederate raiding party searching for contraband shoes collided with Union cavalry, and after reinforcements arrived for both sides, heavy fighting took place.

On the third day of the battle, Pickett's Division—with the Eighteenth Regiment in Garnett's Brigade and the Thirty-eighth, Fifty-third and Fifty-seventh Regiments in Armistead's Brigade—took their positions along the slope of Seminary Ridge. The terrain was already littered with bodies, shattered trees and gaping holes punctured by exploding shells. Garnett's Brigade with the Danville Blues and Grays and the Spring Garden Blues lined up along the crest of the ridge. Behind them, Armistead's Brigade with the Chatham Greys and all the other companies from the various communities of Pittsylvania County lined up as well.

At 1:00 p.m., the Southern cannons bombarded the Union position at Cemetery Ridge across the wheat field. The Union cannons responded as the bombardment went on for two hours until the field was covered with smoke that resembled a shroud for the dead. Men rose to form for the attack. Friends said their goodbyes; some soldiers sang hymns. No one questioned General Lee's orders as their courage rose to new heights. General Armistead strode along the line shouting, "Remember men, what you are fighting for. Remember your homes and your firesides, your mothers and wives and sisters and sweethearts."

Nearly fifteen thousand men, in a line that stretched for a mile, faced the Union army perched on the ridge beyond the Emmitsburg Road. As the soldiers moved forward in silence, regimental flags caught the breeze and flashed their colors in the sun. Gleaming bayonets on muskets at shoulder arms stretched left and right as far as the eye could see. The men marched in perfect order with the precision of soldiers in a dress parade.

A mile away across the open field lay the enemy in wait. As the Union army gunners saw the mass of Confederates approaching, they released a terrible cannon fire that tore holes in the Confederate lines. But the gaps were quickly filled and on the long gray line marched, unflustered by the terror. Chatham physician Rawley Martin recounted that day at Gettysburg with sobering words:

> *The scene was grand and terrible, and well calculated to demoralize the stoutest heart, but not a step faltered, not a face blanched. The Federal*

> *batteries open fire…Still forward they go; the hissing, screaming, shells break in their front, rear, on their flanks, all about them, but they press forward, keeping step to the music of the battle…Suddenly, the infantry behind the rock fence poured volley after volley into the advancing ranks. The men fell like stalks of grain before the reaper, but they closed the gaps and pressed forward, through the pitiless storm. Great gaps have been torn in their ranks, their field and company officers have fallen, colorbearer after colorbearer has been shot, but they never faltered.*

As the Confederates neared the wall, Armistead, the only brigade commander left, advanced waving his sword with his hat perched on the top of the blade. He turned to Colonel Rawley W. Martin of the Chatham Greys, by now Fifty-third Regiment commander, and shouted, "Colonel, we can't stay here; we must go over that wall!" Rawley Martin responded, "Then we'll go forward." Armistead followed with a shout, "Give them the cold steel boys!" Nearly three hundred Virginians, including Pittsylvania soldiers, erupted with a spine-chilling Rebel yell. As they clambered over the stone wall below Cemetery Ridge, they faced a withering mass of exploding guns and cannons. Not to be denied, the Southerners persevered, briefly routing the Seventy-first Pennsylvania.

The dense smoke of musketry disguised the men but not the sound of curses, oaths, loud cries and yells. Dead Union and Confederate soldiers were piled up in "ghastly heaps." Armistead was mortally wounded and next to him Rawley Martin, his left leg shattered, and Thomas Tredway of the Chatham Greys, who came to Martin's assistance, was shot dead and fell across the colonel's body. Other Pittsylvania County soldiers made it across the wall but were captured, as was Rawley Martin. Private James Carter Jr. was wounded, but Lieutenant H.L. Carter, also of the Greys, carried the Thirty-eighth's regimental flag into the Yankee stronghold before he was captured.

The battlefield was a carpet of corpses and a wasteland of wounded warriors. Lieutenant James Wyatt Whitehead of Company I of the Fifty-third Virginia wrote:

> *I lay on the battlefield two nights and a day before my captors removed me and no one will ever know what I suffered both physically and mentally. I think one could have walked 50 yards in any direction from where I lay on the field stepping from one dead man to another without putting foot to the ground.*

Pittsylvania County, Virginia

Rawley White Martin, a Chatham physician and Confederate colonel, fought heroically with the Chatham Greys during Pickett's Charge at Gettysburg in 1863. *Photo courtesy of Desmond Kendrick.*

Although Whitehead and other Confederate wounded were captured, General Lee's army retreated back to Virginia from the three days of battle with its own wagon train of wounded stretching seventeen miles. Among them was this author's great-great-grandfather James T. Davis, wounded in Pickett's Charge.

Gettysburg was the turning point of the war and eventually led to the surrender at Appomattox. Yet, this battle more than any other before or since, from colonial times to the modern age, defined forever the bravery, determination and absolute courage of Pittsylvania County soldiers. "Pittsylvania should be proud of her record on that battlefield," added Lieutenant Whitehead, "for she furnished very many more soldiers for Pickett's Charge than any other county in Virginia."

Along with soldiers in the field, Danville and Pittsylvania County both served the Southern cause in other ways. Because of Danville's relative isolation from strategic battle areas, the Confederate government began moving many departments and operations to the town in 1862. William T. Sutherlin became Major Sutherlin, quartermaster of the Danville military post, in charge of overseeing the stockpile of supplies of nearly every item that a soldier would need in the field.

The Civil War

An arsenal was established that employed 115 men who manufactured cartridge boxes, bayonets, horseshoes, leather belts and various other items necessary for maintaining a musket; they also repaired weapons. Two gun manufacturers in Danville also produced weapons. The Danville Manufacturing Company shipped large quantities of woolen cloth to Richmond. Also in 1862, hospitals were established in Danville to care for wounded Confederate soldiers, and during the war 1,074 of them died in these hospitals, the burial sites of most a mystery to this day.

In Chatham, Candidus Bilharz, an immigrant from Germany, and Colonel Coleman D. Bennett started a gun factory located in a tin shop/foundry building right off Main Street. The thirty-eight employees for Bilharz, Hall and Company produced two types of carbines for the Confederacy. An industrial complex referred to as the Birch Creek Works began as a small gristmill on Birch Creek in 1783. It blossomed into a site complete with sawmill, foundry, a machine shop and blacksmith shop, plus other buildings. In addition to producing plow points, iron stoves, saws, tobacco flues, threshing machines and various like items, tradition suggests it may have made some of the cannons used by Confederate forces at Gettysburg.

While Pittsylvania and Danville soldiers marched and fought, and the local communities hummed with war activities, thousands of refugees made their way to Danville, as well as large numbers of Union prisoners shipped by rail to be housed in the town's tobacco warehouses. The six prisons became rat-infested, overcrowded and cold, with the prisoners living in squalor, existing off poor rations and drinking muddy water from Dan River. Naturally, escape attempts were tried on every hand, some being successful. Once, they cut a hole through the ground one hundred feet long, according to former slave Lorenzo Ivy. "De hol led to a branch ravine. Prisuners 'scaped to everywhere from dis hole. Dey discovered de hole one day when they paved de streets years later."

Smallpox reached epidemic proportions among the prison population, requiring hospitals to be established for the sick Union captives. The townspeople did all they could to alleviate the suffering, prompting one surviving patient to recall that being at the hospital was "a little piece of heaven." Methodist ministers John Forbes and Charles Hall, as well as Episcopal rector George W. Dame, visited the hospitals and prisons, bringing food, books and tobacco to the men. Commandant of the Danville Post, Colonel Robert E. Withers, also visited the Union soldiers. Hospital steward Solon Hyde later said, "From what I saw, I think they did the best they could for our sick in Danville." At least 17 percent of the Union

prisoners died—still a lower percentage than those Confederates who died in Federal prisons.

While prisoners suffered from food shortages, so did the townspeople. During the winter of 1864–65, food items became scarce not only for civilians but also for the army. The government had enjoined Pittsylvania County citizens "more earnestly to contribute of their supplies to the sustenance of the forces in the field." Major Sutherlin sent officers into the countryside to "search corn cribs and smokehouses for provisions to send to the army."

Patricia Mitchell, in an article for the *Pittsylvania Packet*, includes excerpts from the Civil War diary of Lieutenant James D. Cope, a Yankee soldier captured at Petersburg in June 1864. Along with other prisoners, he was marched through Pittsylvania County in July on his way from Libby Prison in Richmond to Macon, Georgia. He mentions crossing the Staunton River, Stinking River and George's Creek en route to Pittsylvania Courthouse, "a nice little place." He further wrote, "It was Sunday and the negroes were out en masse to see the Yankees pass, thinking it must be all of Grant's army."

With the weather extremely warm, the citizens placed barrels of ice water out along the street for the prisoners to quench their thirst. As some were passing Carter's Hotel, one prisoner stopped to get a drink and a guard struck him and ordered him to move on. A lady rebuked the guard for being so cruel, so the guard then allowed the man to drink as much as he wanted. The Yankee prisoner looked back as he marched away and said, "God Bless You, Lady."

After crossing the Banister River below Chatham, the prisoners encamped in a field across from Oakland, where lived the widow Lucy Carter. She took pity on the soldiers and had her slaves work late into the night baking cornbread and no doubt other items for them. Other local citizens, including Dr. Rawley Martin, who had been captured at Gettysburg and later paroled, brought food items. The prisoners marched on to Danville and boarded a train for Georgia.

As the war progressed and the threat of enemy attack became more real to the people of Danville, the town became a fortress encircled by entrenchments, earthen forts and gun emplacements. This effort served to prepare Danville for its week of destiny, April 2–9, 1865.

On April 2, 1865, the telegraph at the Danville and Richmond Depot announced that the Confederate government was abandoning Richmond. That afternoon, eight trains were readied to take Confederate officials and important documents to Danville. Attached to the train were two cars carrying the Confederate treasury of approximately $500,000 in gold and silver and guarded by cadets of the Confederate Naval Academy.

The Civil War

After traveling through Pittsylvania County on the last leg of their trip, Confederate President Jefferson Davis and his cabinet arrived in Danville. Major Sutherlin invited Davis and Treasury Secretary Trenholm to stay at his Main Street residence, known today as the Sutherlin Mansion. Other wealthy citizens opened up their homes for other officials. In the days following, government operations were set up in the Benedict House on Wilson Street, and the Bank of Danville served as the Confederate Depository. Danville literally became the "Last Capital of the Confederacy." With the arrival of Virginia's governor William "Extra Billy" Smith from Richmond, the new state capital was also established in Danville.

With the abandonment of Richmond, more refugees arrived daily in Danville, as well as three thousand Confederate troops sent by General Beauregard. At the same time, Confederate captain John Dooley of Richmond, who had been wounded, captured and paroled, crossed into Pittsylvania County at Pannill's Bridge on his way from Amherst County. He wrote:

> *Stragglers from Lee's army are flowing by us in crowds. The army is completely disorganized, and everyone for himself is the sole idea. We borrowed a mule from negro boy named Hiram…As we approach Danville the roads become thronged with stragglers of all descriptions, wagon loads of people and their effects, moving into Danville, and crowds moving from town…All is confusion and panic.*

On April 4, Admiral Raphael Semmes and four hundred sailors from the James River Squadron arrived by train to man Danville's defenses. Also that day, from the Sutherlin Mansion, President Davis penned his last proclamation to the Confederate States, declaring that the "sacred cause" would not be abandoned.

Five days later, General Robert E. Lee surrendered the Army of Northern Virginia at Appomattox, Virginia. The news arrived to Davis and his cabinet on April 10 and fell upon them like "the paralyzing shock of an earthquake." By 11:00 p.m. that night, Davis and his cabinet had left Danville via the Piedmont Railroad through Pittsylvania County on the way to Greensboro. They had been preceded the previous day by a train carrying the naval cadets and the gold.

On April 15, 1,500 men of Confederate brigadier general John Bratton's brigade of paroled Palmetto Sharpshooters from South Carolina marched together from Appomattox. As they marched through Chatham, Mrs. Lucy

Carter treated the hungry men to a feast at her mansion. The meal consisted of Virginia ham, homemade bread, fried chicken, cakes, tarts and pies. The men continued their march through Danville and boarded trains in Pelham, North Carolina, for home.

A week later on April 27, at 9:45 a.m., Union soldiers of Major General Wright's VI Corps crossed the bridge at Fall Creek on the Halifax Road in Pittsylvania County just east of Danville. There the town of Danville tendered its surrender, followed by the arrival of the rest of the VI Corps. Lawrence McFall, in his *Danville in the Civil War*, records, "From Fall Creek, the long line of infantry, artillery and the wagon train slowly wound along the road paralleling Dan River."

On April 30, 1865, a Union officer from Rhode Island named Elisha Hunt Rhodes commented on his opinion of Danville, noting that a lot of Confederate officers still wore their uniforms and were often rude to his men.

Danville and Pittsylvania County at once came under military rule, occupied by the very army that its men had fought against for four long years. On May 16, the VI Corps left the way they came, across Fall Creek, through Pittsylvania County, headed toward Richmond. General Wright did leave the Twelfth New Hampshire and a portion of the Twentieth New York Cavalry at Danville until June 13 to maintain order.

Thus ended the Civil War for Danville and Pittsylvania County. According to McFall, 4,324 Danville and Pittsylvania County men served in various units of the Confederate army. There were also black soldiers from Pittsylvania County who served in the Confederate army. A slave on the Swanson plantation, Bob Tarpley, served as a blacksmith with Confederate forces, manufacturing breastplates used by soldiers for protection. He died at 110 years old in 1941 with 208 descendants. Green Minter, another slave, accompanied his master to war and afterward settled in the county. The 1880 census lists him in the Dan River district with a wife and seven children.

At least one woman from Pittsylvania County fought with the South. C.N. Saussy was imprisoned in Point Lookout, Maryland, and remembered that "a captured Confederate, a member of the Pittsylvania, Va., Battery… revealed to the authorities the female sex, and gave her real name as Jane Perkins. Arrangements were made for her release."

Hundreds of Confederate veterans lie buried beneath the soil in Danville and the county—soil they so adamantly defended. In Danville's National Cemetery lie the remains of approximately 1,300 Union prisoners who died

The Civil War

Danville's National Cemetery on Lee Street originated in 1866 with the burial of Union prisoners of war who died mostly of disease in Danville's Civil War prisons.

in Danville prisons and hospitals and an unknown number of Confederates who also died in Danville's hospitals.

The cost of the war was extreme as both sides sacrificed their fathers, husbands and sons in that grand duel that killed more Americans than any other war past or present. The Confederate statue in downtown Chatham and the Confederate memorial in Danville are more than monuments to men wearing gray—they are tributes to the honor that these men clothed themselves in, not only that fateful day at Gettysburg, but also in the other battles of that great conflict. In the words of historian G. Howard Gregory, "These brave soldiers, like Americans in every war, answered the call to duty and fought to the last for their country and for a cause they perceived as just and true."

CHAPTER 12

HARD TIMES AND RECOVERY

By the end of the Civil War, the Southern states were devastated and destitute. Money was worthless and credit nonexistent. Missing from the farms were many sons, fathers and brothers who died on bloody battlefields. Freed slaves were no longer obligated to the plantations, and sons of the owners sought employment elsewhere. Along with Reconstruction policies designed to punish the southern states, recovery did not come easy.

The Reconstruction period was the era of carpetbaggers, northerners who came south, and scalawags, white southerners who supported Reconstruction policies in Congress. Both joined with freed blacks to form coalition political parties that took control of local and state governments in the South.

The 1880 census showed that blacks outnumbered whites in both Pittsylvania County and Danville. The majority black population in the town set the stage in 1883 for Danville to become immersed in a political crisis. After a local election, the city government came under black control with a black mayor, four appointed black policemen and seven out of twelve seats on council occupied by blacks. Black citizens presumed that the new government could guarantee their protection as political tensions escalated prior to another election.

However, the November 1883 local state senate seat contest between Republican William E. Sims and Democrat John L. Hurt triggered a dramatic setback for black political fortunes and the Republican Party throughout the South. On November 4 in Danville, Sims addressed his gathered black supporters in a speech described as "incendiary" by his opponents. That

Hard Times and Recovery

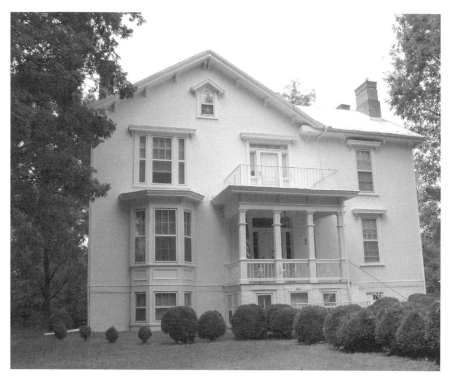

The Sims-Mitchell House at 242 Whittle Street in Chatham owned by Henry and Patricia Mitchell. This Italian villa–style home was built in 1875 for controversial politician Colonel William E. Sims and his family.

rally, combined with tensions already brewing among the races, led to a racial clash that made news across the nation.

According to one report, when a black man in downtown Danville stepped aside for a white woman walking up the sidewalk, he accidentally stepped on a white man's shoe. Though he apologized, that wasn't good enough, and the white man struck him, after which the black man knocked his attacker into the street. Fights followed and eventually pistols, shotguns and rifles were drawn by white adults and youth. An estimated fifty to two hundred shots were fired, leaving at least four blacks dead, a number wounded and two whites wounded. Martial law was imposed, with soldiers and armed citizens patrolling the streets and intimidating the black community, which resulted in a low turnout at the polls.

The downside of this incident illustrates what happened throughout the county, region and state. White sympathies aligned with southern Democrat politics and allowed them to regain control of local governments. Jim Crow

statutes came out of this environment, removing blacks from the political process and legalizing segregation.

Another incident in the county during this era also made national news. In 1878, Pittsylvania County judge J.D. Coles was arrested for failure to uphold the Civil Rights Act of 1875. He had denied black citizens the right to serve as jurors in county court cases. He appealed his arrest and imprisonment, but in *Ex Parte Virginia* the United States Supreme Court ruled that Coles did indeed violate the law. The case stood out as an exception to other rulings in the era and showed that the national government did have power over the civil rights of all Americans. Still the Civil Rights Act that Coles was accused of violating was struck down by the Supreme Court in 1883 as unconstitutional. Along with other rulings, racial discrimination was assured of lasting into the next century.

As an example, employment tended to follow racial lines. Freed blacks found employment in tobacco factories and warehouses toiling alongside white workers, but black workers were given the more menial tasks. When textile manufacturing firmly took hold in the area, the mills employed mostly white workers.

Even as a racial hierarchy found its way into industry, textile manufacturing provided a significant stimulus to the local economy. On July 27, 1882, Riverside Cotton Mill was chartered to produce cotton and woolen fabrics. More mills were built as the company expanded. In 1895, some of the Riverside founders launched the Dan River Power and Manufacturing Company to harness the water power of the Dan River. The mill and its later expansion mills were located in what became known as the Schoolfield area, named after the three Schoolfield brothers who were instrumental in establishing the local cotton mills. Schoolfield remained part of the county until it was annexed by Danville in 1951.

Beyond benefiting the economy, the cotton mills also prompted another change. The north bank of the Dan River opposite Danville's Main Street Bridge had previously been a forested area bisected by the road leading from the bridge to Pittsylvania Courthouse. Grain mills using the river's water power were already in operation there before the Civil War, but the north side remained sparsely populated. Then in 1882, when Riverside Cotton Mill's number two mill was established on the grain mill site, settlement of the north bank increased.

In Jane Hagan's words in *The Story of Danville*, "The establishment of a Cotton Mill on the north side gave marked impetus to the settlement there and growth was rapid in the next few years, many citizens preferring the greater

Hard Times and Recovery

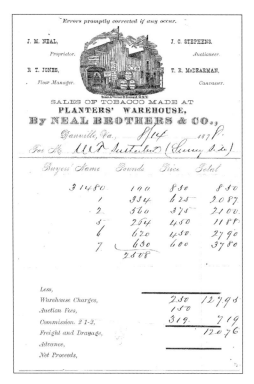

A tobacco sales receipt made out to W.T. Sutherlin in 1878 from Planters' Warehouse in Danville. Sutherlin was a prominent county farmer and industrialist, as well as a Danville citizen. *Photo courtesy of Desmond Kendrick.*

elevation and broad outlook of that locality." The village came to be called Neopolis, named after the beautiful city of Naples, Italy, and in 1896 requested to be annexed to Danville.

Tobacco sales also revived after the Civil War. To the Danville system of selling loose-leaf tobacco from the warehouse floor was added the auctioneering chant. Buyers followed the auctioneer along from pile to pile bidding on tobacco. The Danville system increased tobacco production from Pittsylvania County and allowed the county and city to recover more quickly from the devastation of the Civil War than many other areas of the state.

The demand for Virginia's Bright Leaf tobacco was so great that by 1885 there were 122 leaf dealers in the Danville market with well-established local firms such as Dibrell Brothers. Danville became the world's largest Bright Leaf tobacco market, and in 1899 sales were valued at over 54 million pounds. Large tobacco firms from outside Virginia such as Liggett and Myers, R.J. Reynolds and P. Lorillard not only sent their buyers but also built large re-drying and storage plants in the area.

Besides the jobs that tobacco and textiles brought to Danville and Pittsylvania County citizens, prominent benefactors shared their wealth with the community. One local tobacco exporter, J.E. Hughes, was extremely successful and left a huge estate that helped established in later years Hughes Memorial Home for orphans and Danville Memorial Hospital.

Tobacco and textiles were not the only industry to thrive in Pittsylvania County. Mining commenced in earnest in the northwestern part of the

county in the late nineteenth century. In the colonial period, Colonel John Donelson had exploited iron deposits in Pittsylvania County at his ironworks, the Bloomery, which was located at what is now the southern boundary of Rocky Mount in Franklin County. From the 1880s to the early twentieth century, open-pit iron mines producing abundant ore were located in the area of Pittsville, hence the name.

The *Visitor's Guide to Early Industry in Pittsylvania County* notes eleven barite mines scattered from Toshes to Whittles. From the processed ore came a valuable component used in drilling mud for the petroleum industry and in internal medicine as a barrier to X-rays. Other rock material mined in various areas of the county included marble, feldspar, manganese and granite.

It was natural for schools to follow the lead of industry and agriculture and to develop accordingly. In 1870, the Virginia General Assembly reestablished free schools that were highly organized from the state to local level. Every county had a school superintendent, with each school district having a board of trustees. The state imposed an annual property tax for the benefit of the schools. By January of the following year, according to one count, three thousand public schools with 136,000 children existed in Virginia.

Teachers also had to be enlisted. In 1891, Lizzie Guerrant signed a contract with the board of trustees of the Tunstall School District of Pittsylvania County to teach school. Her agreement obligated her to teach in the Whitmell schoolhouse for five months for twenty-seven dollars per month. She had to be prompt about making her reports to the county superintendent or be fined up to five dollars. She was also responsible for making a fire and ensuring that the floor was swept regularly.

In addition to public schools, notable private schools sprang up during the postwar period. Chatham Hall, originally named Chatham Episcopal Institute, was opened in 1894 by Reverend C.O. Pruden. It featured a rigorous academic program for educating young women in Virginia and North Carolina. In Danville in 1890, Danville Military Institute was chartered as a high grade preparatory school for young men. The War Department sent instructors in military science and supplied necessary ordnance.

Advertisements from the *Pittsylvania Tribune* from 1877 to 1890 provide a window into the local business community in the last quarter of the nineteenth century. In the February 1885 issue was the following: "B.S. White livery and feed stable, main street, Chatham. Driver will find convenient lots and good accommodations for horses and mules." Others read: "J.S. Hargrave keeps a full supply of Old Hickory and Tennessee wagons for sale"; "C.D. Mott,

Hard Times and Recovery

Pruden Hall on the campus of Chatham Hall, established in 1894 as the Chatham Episcopal Institute by Reverend C. Orlando Pruden for the education of young women.

Chatham, has coffins, burial robes. Just received a fresh supply of walnut coffins from longest to smallest. Also burial robes for ladies and gents. My stock can be seen over Jones Store"; and "R.F. Luck opened on November 1, 1884 in Chatham to do roofing, guttering and spouting on short notice."

An 1878 map of Chatham published by O.W. Gray and Son shows Main Street connected to Ward Springs Road leading to points north and Halifax Road branching off to the east. Chatham's town limit was on the southwest end by the Washington City Virginia Midland and Great Southern Railroad line, with the freight and passenger station off Depot Road.

Besides the courthouse on Main Street in Chatham, there existed a public school, the Chatham Savings Bank, a carriage manufacturer, a drugstore, post office, several stores including a tin and stove store, three tobacco factories including that of J.D. Coleman, law offices, a hotel, the *Tribune* office and the Masonic Hall, plus residences. The Episcopal, Presbyterian and Methodist Episcopal churches stood on Main Street, and the "colored Methodist church" and "colored school house" along with a "colored Baptist church" were near the southern border of the town.

No taverns were featured on the map; however, it did feature the Bolanz Distillery on Tanyard Branch. There was, of course, a whole lot of drinking going on in those days. From 1877 to 1890, the *Pittsylvania Tribune* listed at least twenty-three saloons—just about one on every corner in Chatham, and that doesn't include any other establishments lawful or unlawful. One

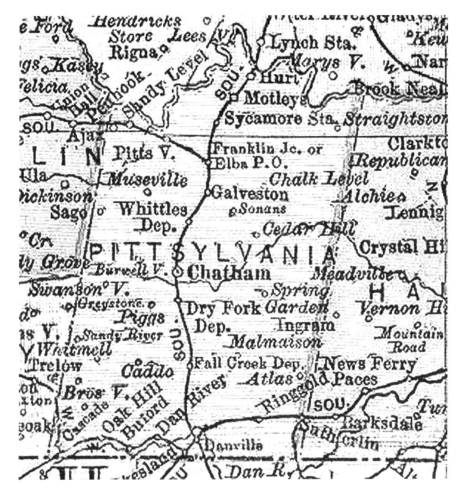

Pittsylvania County in 1895 from the *U.S. Atlas* published by Rand McNally. *Courtesy of Pam Rietsch and USGenNet.org.*

of the front-page advertisements for liquor by the drink was the following: "W.T. Hardy dealer in fine whiskeys, Main St, Chatham. You will find me at my place of business at all hours, day or night." Or this one: "For the best whiskey, brandy, wine or beer, call at J.R. Yates saloon, opposite Carter's Hotel, Chatham and you can be supplied by John L. Cary, who is managing for me. John R. Yates." Another ad read "Wm E. Goolsby Saloon at the Depot. A barrel of pure brandy just received."

Herman Melton recites the story of the Chatham Riot of March 1875. A fire in a boardinghouse near the present-day courthouse threatened to consume the entire town. A tavern nearby erupted in flames and the owner,

Hard Times and Recovery

attempting to save his barrels of whiskey, rolled them out into the street. A crowd gathered around the barrels, helped themselves to the whiskey and, according to a newspaper report, got out of control. Fortunately, the courthouse was saved but not the whiskey. The fire was linked to arson, but the sauced-up mob didn't make things any better. As Melton notes, "It was not a good night in Chatham history."

While drinking was just a normal, everyday thing, murder wasn't. Sensational murder trials were all too frequent, but one stands out above the rest. During that time, not only did the heinous crime make the headlines, but it also became a country folk ballad still sung today. Joe Clark wasn't old but would have been had he not been hanged for murdering Albert Barksdale.

Herman Melton in *Southside Virginia* relates that Joe was born just east of Chatham off Route 703 and grew up as a plantation slave. He continued to work there as a field hand during Reconstruction days and then went to work in a Chatham tobacco factory. Joe had an affinity for women, which led him to engage in an affair with Nancy Barksdale. She was the wife of Albert, who was away from home for extended periods due to his railroad job in Maryland.

Joe Clark, presumably married with children, visited Nancy indiscreetly; his actions were soon noticed by friends and neighbors of Albert Barksdale. Albert found out, became jealous and returned home permanently to another job so he could keep an eye on the situation. According to a Danville newspaper story relating Joe's confession to the county jailor, Joe made up his mind to kill Barksdale and struck him in the back of the head with a large rock at a convenient time.

Joe kept up the rendezvous with Nancy until Albert's body was discovered. Joe Clark's alibis didn't hold up, and he was indicted and convicted of murder in the first degree, the evidence and witnesses being strongly against him. Joe was hanged on April 30, 1875, in front of a large crowd. In his last statement, he agreed that he was justly condemned by the laws of God and man, though he believed Nancy Barksdale was the cause of the whole affair and ought to be hanged with him.

More pleasant events than murder were associated with the 1870s. Lady Nancy Astor, the first female member of the British Parliament, was born in Danville in 1879. Her father, Colonel Chiswell Langhorne, is credited with the auctioneering chant once so popular at tobacco warehouses. Her sister, Irene Langhorne Gibson, had been born five years earlier and became a model for the famous Gibson Girl images, the

Pittsylvania County, Virginia

Briarwood, an example of Neoclassical and American Foursquare architecture built in the early 1900s on Cherrystone Road below Chatham, was once the home of Congressman Joseph Whitehead.

feminine ideal of the early twentieth century, illustrated by her husband, Charles Dana Gibson.

In March 1876, Major W.T. Sutherlin received a charter for the Milton and Sutherlin Narrow Gauge Railroad, a seven-mile track between the two communities that enhanced his business opportunities as a freight carrier. He also promoted the Danville and New River Railroad that stretched from Danville to Stuart, Virginia, a distance of seventy-five miles. Its name was changed later to Danville and Western but became known as the "Dick and Willie."

Railroads became one of the nineteenth century's major advancements affecting Pittsylvania County. It was a century that saw its share of turmoil in slavery, natural disasters, civil war and reconstruction. But immigrants continued to come to Pittsylvania County, including John H. Graf and his family, who came from Switzerland in 1879 and settled at the base of White Oak Mountain. The century ended with tobacco and textiles bringing growth in prosperity and population to Danville and the county. The next century promised more hope, but even more changes were to come.

CHAPTER 13

THE TWENTIETH CENTURY

Pittsylvania County entered the twentieth century with 46,894 people, many farming the land but grappling with the Industrial Age. The next one hundred years would bring prosperity but also the Great Depression, World Wars I and II, the Space Age and the Internet.

The twentieth century began with the incorporation of a town later to be called Gretna but known then by two different names. The origin of the town goes back to the Civil War, when a wealthy landowner, a young man named Edward Dillard, hired a substitute to face the guns. He had just married and likely did not want to leave his new bride, especially since if he died in battle, he would leave her to someone else. He offered Jeremiah Talbott 408 acres to serve in his stead.

Talbott survived the war and returned to build his first house where Gretna is today. Talbott sold land to others who built stores and houses, too. In 1879, the Franklin and Pittsylvania Railroad was completed and connected the area with Franklin County—a distance of thirty-six miles—and became known as Franklin Junction, with a passenger and freight station. The post office was named Elba. The railroad formed a junction with the north–south Danville and Lynchburg Railroad.

The junction was particularly useful for hauling ore from the mines in the northwestern part of the county to faraway markets. As mining and other activities increased around the railroad stop, a village sprang up that in 1901 had five stores, two livery stables, a hotel, a drugstore and 150 residents. That year, the state legislature incorporated the town. From 1909 to 1922,

Pittsylvania County, Virginia

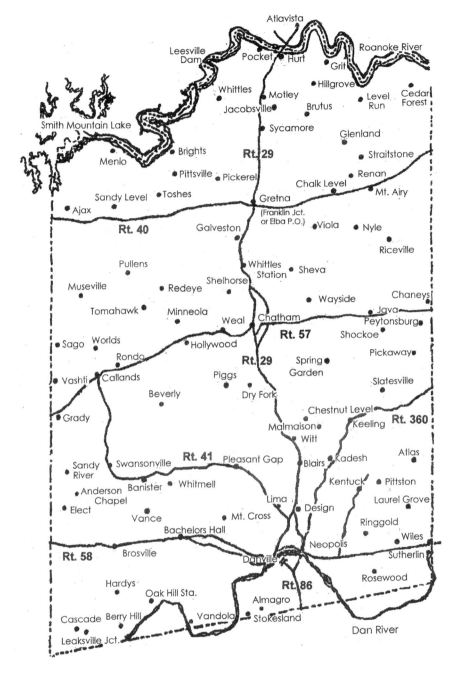

Pittsylvania County, Virginia, circa 1900. Adapted and modified from a map in *Piedmont Lineages*, bulletin of the Virginia/North Carolina Piedmont Genealogical Society.

The Twentieth Century

A painting of the "Wreck of Old 97" by Preston Moses, late editor of Pittsylvania County's *Star-Tribune. Courtesy of Susan Worley.*

tobacco was the main business and the town had four warehouses bordering the dirt streets.

In 1916, the legislature changed the name of the town from Elba Post Office and Franklin Junction Station to Gretna. It appears that the new

name had no connection with anything related to the county. The town council reportedly selected the name from a list supplied by the post office, though the name likely originated from Gretna Greens in Scotland, a small village known for runaway weddings.

Railroads, of course, were a major means of transportation in those days, and the greatest railroad story of that time happened while Gretna was growing; in fact, the town was part of the story.

The most famous train wreck in American history occurred on September 27, 1903. Railroad engineer J.A. "Steve" Broady was a man in a hurry. Train No. 97, under a lucrative government contract to deliver mail from Washington to Atlanta, had priority over other trains, which had to clear the track ahead of it. But on that day, No. 97 was behind schedule. No. 97 also had a reputation as the fastest mail train on the Southern Railway, and Steve Broady, leaving Monroe, Virginia, heading south, vowed to get to "Danville or Hell" on time.

G. Howard Gregory's *History of the Wreck of Old 97* and other sources share the details of what happened next. The train stopped in Lynchburg, then passed into Pittsylvania County, through Hurt and Sycamore, with the "fire box roaring and the safety valve whipping a white feather of steam into the gray smoke flowing in her wake." Next, it stopped at Franklin Junction for water before heading south through the Pittsylvania County communities of Whittles, Chatham, Dry Fork and over White Oak Mountain past Fall Creek Depot. At Lima, located on Franklin Turnpike just north of Danville, Broady pushed the train down a three-mile grade toward a trestle over Stillhouse Creek in North Danville.

Engineer Steve Broady approached the trestle at full speed, but he applied his brakes too late. Sparks flew from the wheels and the train left the track, went airborne and traveled over one hundred feet before landing on its side in the creek bed—its mail cars shattered into kindling. Clay Pritchett, an eyewitness, commented about the crash in 1942: "It sounded like the mighty roar of tremendous thunder and the dust was like a mighty cloud before a huge storm."

Broady's body was found some distance from the engine horribly mangled. Altogether, nine men were killed and seven injured. Yellow canaries, supposedly on their way to West Virginia coal mines, flew around the wreck for a long time. Small boys climbed up on the turned-over locomotive and rang the bell, as if sounding a requiem for the dead.

Train wrecks were not uncommon, but this one became famous because of a song, "The Wreck of Old 97," written by David Graves

The Twentieth Century

Chatham's Railway Station, circa 1976, by Pittsylvania County artist Wilson G. Hibble. *Photo from BB&T Collection in Chatham.*

A twentieth-century Dan River Mills building along the Dan River in Danville featuring its landmark sign. *Photo courtesy of Richard Davis.*

George, a telegraph operator at Franklin Junction who arrived at the scene sometime after. Due to a conflict over copyright, it wasn't until 1934, after a Supreme Court decision, that George won his case against Victor Talking Machine Company and finally received his royalties. This ballad was the first country song to sell over a million records and artists still record it. Dan Akroyd referred to it in the classic movie *Blues Brothers* as typical of country music songs.

Collateral damage around the train wreck included a red brick cotton warehouse belonging to Riverside Cotton Mills. But one train wreck would not put the textile company out of business. Several mills were operating at that time, and in 1909, that company joined with Danville Power and Manufacturing Company to become the Riverside and Dan River Cotton Mills. By World War I, the mills operated 315,000 spindles and ten thousand looms, with mill buildings located throughout the area. The combined sales in 1920 were in excess of $30 million. The name Dan River Mills became official in 1945, and the company went on to become a nationally established brand name, manufacturing all kinds of fabrics and cotton goods.

In the midst of the textile boom, World War I erupted. The *Pittsylvania Tribune* reported that "the county saw its own soldiers go off to war, some to be wounded, or to die, in places like Flanders's Field. Twenty-five of the county's sons died on the battlefield." Among the wounded was Chatham resident Thomas Moore Overbey, who had been blinded and crippled by mustard gas in the Argonne and confined to a wheelchair until his death on September 18, 1928.

Another county resident, Lieutenant Hunter Pannill, served with Canadian forces in France. With his superior officers out of action during a battle, Pannill led his force to victory. He received the Victoria Cross at Buckingham Palace from King George of England for bravery at Vimy Ridge in April 1917.

Pittsylvania County's mining industry also played a part in World War I. Whittles Emery Mine opened in 1917 and extracted the ore needed for the processing of steel in World War I. Emery was normally imported from Turkey, but with the country at war with Turkey only two mines, one in New York and the one in Pittsylvania County, were available to supply the ore. The emery was hauled by wagons and trucks to the Southern Railroad depot at Whittles and shipped from there.

When the war came to a close in 1918, the *Tribune* recorded the reaction in the county seat:

The Twentieth Century

A 1920 Hudson car parked on Main Street in front of the Chatham Savings Bank. *From the Glenn B. Updike Sr. Collection of the Pittsylvania County Historical Society.*

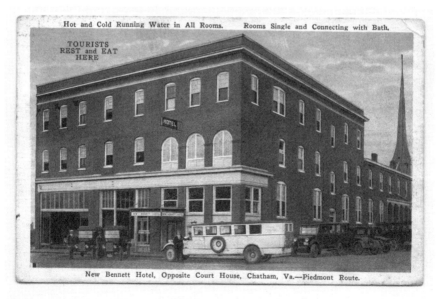

Postcard depicting the New Bennett Hotel along Main Street in Chatham during the early twentieth century. *Photo courtesy of Dr. William Black of Chatham Hall.*

The main hall of Hargrave Military Academy, a military boarding school founded in 1909 in Chatham and named after organizer J. Hunt Hargrave, a local businessman.

> *In Chatham a fire bell in the courthouse steeple rang out the tidings of peace, and the word went from house to house. A spontaneous parade soon formed with a bunch of musicians from the theatre being drawn in a wagon by the jubilant crowd. The parade ended up at the old CEI (Chatham Hall) with a big bonfire, and one gentleman tossed his hat in the flames saying, "Suppose that was made in Germany." There was sheer joy for everyone in knowing there would be no more fighting.*

At the end of the war, the 1920s heralded the era of the flapper, jazz, bootleg whiskey, novels of F. Scott Fitzgerald and Thomas Hardy, soda jerks and ice cream. Pittsylvania County women staged a parade along Chatham's Main Street in support of the women's suffrage movement, and in 1925, Hargrave Military Academy, established as Chatham Training School for boys in 1909, was named after J. Hunt Hargrave, a prosperous local industrialist.

Camilla Ella Williams, who was born in Danville and grew up during the 1920s, became the first black soprano with the New York Opera and went on to achieve international acclaim. Wendell Scott, also born in Danville during the 1920s, became the first black NASCAR race driver to win a

The Twentieth Century

Grand National (later the Winston Cup) Race. He actually started racing hauling contraband liquor, outrunning the police many times on Pittsylvania County roads. The Hollywood movie about his life is appropriately named *Greased Lightning*.

Illegal bootleg whiskey in the 1920s was encouraged by Prohibition, which began with the Eighteenth Amendment that outlawed the manufacture, sale and transportation of alcohol. Saloons had flourished in Pittsylvania and for decades before that time merchants had licenses to sell whiskey. Prohibition changed the drinking habits of Pittsylvanians in general and in a hurry. Not only was liquor by the drink outlawed in saloons, but what had been the legal manufacturing of it was stopped as well. Edward and Sidney Jones had previously advertised their Dry Fork Distilling Company as "distillers and shippers of pure 100 proof corn whiskey." With Prohibition the company renamed itself Dry Fork Milling Company to indicate a change of direction.

Prohibition put a stop to the legal liquor trade, but federal agents then as now were on the prowl looking for illegal stills. Interfering with a practice that their ancestors had freely enjoyed during colonial times up to the twentieth century did not sit well with county residents. They resisted.

In *The Paradox of Southern Progressivism 1880–1930*, author William A. Link relates the following story:

> *A well-armed mob greeted a raid on a rural still near Gretna, in Pittsylvania County, in 1922. The agents destroyed a large still and confiscated 1,500 gallons of mash, but, as one of them put it, they were resisted by "a great number of men seeking our lives." Wisely, officers decided to get out while they could, as the bullets whistled close to their faces.*

The era of Prohibition ended in 1933 but not before the advent of the Great Depression, which lasted well into the 1930s. Out of that depression, born and reared in Danville, came James I. "Bud" Robertson, who has since become a national and international authority on the Civil War, as a writer and also consultant to the television and movie industries on that conflict. He has won every major award in the field of Civil War history.

The Great Depression hit the county hard in 1929. During the stock market crash, prosperity disintegrated. Banks closed, unemployment increased and wages were cut. Families in Pittsylvania County lost crops, farm implements and even farms. Prices of goods went up drastically as the value of the dollar dropped. Some parents could not send their children to school because they had no money for clothes or shoes.

PITTSYLVANIA COUNTY, VIRGINIA

In November 1930, just a year after the stock market crash, Governor Pollard was confronted with a textile strike in Danville. After depressed economic conditions resulted in a 10 percent wage reduction and more work piled on millworkers, the United Textile Workers labor union initiated a strike sending four thousand mill employees out on the street. Workers were forced out of their company homes and their families passed Christmas that year in shelters or tents. Tempers were high and violence erupted off and on from November through January.

According to Jane Hagan in *The Story of Danville*, bombs were thrown and houses were damaged, especially that of Police Justice Fitts, whose home was partly blown away while he occupied the house. The governor was forced to call out the National Guard to restore order when the strikers attempted to block the highway at the village of Schoolfield. When the workers voted to end the strike in January 1931, many of them were not rehired due to economic conditions and a decline in business that resulted from the strike.

Those who raised the money crop tobacco suffered severely during the Depression. Tobacco prices plummeted. In his book, *Depression and New Deal in Virginia*, Ronald Heineman relates that during the Depression a Danville tobacco warehouse official recalled the farmers' anguish: "We find men actually weeping after they have had to sell their tobacco at prices that will mean nothing less than complete disaster."

Tobacco farming had been part of a growing agricultural market for the county. In 1900, Chatham was a thriving tobacco center with three auction warehouses, along with factories turning out smoking and chewing tobacco sold all over the United States. Yet, even though the Depression severely hurt tobacco sales, by 1933 the government had instituted a tobacco price support system and also government loans to farmers. In earlier days, there was no guarantee that tobacco would sell, and when it didn't farmers were forced to take it back home. When the government became involved, it allotted so many acres to the farmer and monitored the supply and demand for tobacco, which was guaranteed to keep the price up. Tobacco farming once again prospered.

In the 1950 agricultural census, tobacco, as well as other crops and farm products, continued their growth. In Pittsylvania County, 4,690 farms yielded 33 million pounds of tobacco, along with substantial amounts of corn, wheat and dairy products. Over fifty sawmills supported a thriving lumber industry.

The development of education in Pittsylvania County also saw dramatic changes in the twentieth century. At the beginning of the century, two-room

schoolhouses were commonplace throughout the county. At one time, 130 existed. Typically, they were log or frame buildings with a potbellied stove in the center with no bathrooms, running water, electricity or cafeteria. Most schools only went as far as the eighth grade. High schools were in the future.

Public education had been revived in the 1870s, and public schools and private schools existed side by side during the following years. Almost every community in the county had them. The schools functioned as community centers, hosting social and business activities, but many were closed during the 1930s and 1940s.

Schools began to consolidate, and high schools allowed students to achieve a higher education than previously offered. By 1950, ten high schools existed in the county: Brosville, Callands, Chatham, Climax, Dan River, Gretna, Schoolfield, Spring Garden, Renan and Whitmell. Two high schools for black students existed on opposite ends of the county—Northside at Gretna and Southside near Danville. The high schools that year enrolled 2,348 students and the elementary schools 7,900.

Of the high schools, Whitmell was the most unique. It consisted of two rooms when Sarah Archie Swanson Beverley attended there. By 1916, Beverley was back at Whitmell teaching seventh grade at her old school. By the next, year she was also principal.

However, over time, Mrs. Beverley developed a new protocol for education. In her book, *Growing Years: The Development of Whitmell Farm-Life School*, she described her new vision for rural education. She believed that children should not be handicapped with only a minimum elementary education because they did not live in a large and prosperous community. She also believed that the school should be the center of the community:

> *From the school must flow streams of influence…more beautiful and comfortable, scientific methods of farming and getting away from one crop idea…The school is the logical center, for here and here only may be gathered all the children of all the people, and through this institution only may the whole community be reached.*

With this philosophy, Mrs. Beverley made Whitmell Farm-Life School one of the most advanced rural schools in the South. She introduced agriculture, home economics, shop work, business, art, music and drama.

The school became a national phenomenon. In 1920, the National Conference on Rural Education was held there. In the July 1923 issue of the *New England Journal of Education*, Editor Dr. A.E. Winship wrote, "Whitmell,

Claude Augustus Swanson of Pittsylvania County in 1905, during his tenure as a United States congressional representative from Virginia. *Courtesy of Library of Congress.*

Virginia is deservedly famous...it has one of the most interesting consolidated schools in the United States." In time, Whitmell Farm-Life School became the first rural school in the county accredited by the Virginia Board of Education.

By 1944, Mrs. Beverley was chosen to represent Virginia as one of 230 leaders in education, government, labor, industry and agriculture to be invited to the White House by President and Mrs. Roosevelt for a conference on rural education. Achieving such national recognition was a result of her hard work as teacher and as principal from 1916 to 1951, a total of forty-three years. She is duly remembered as "a beacon leading others to the light of education."

Mrs. Beverley's brother, Claude Augustus Swanson, was equally remarkable as Pittsylvania County's most famous politician. He was born in 1862 in the Swansonville community on a chilly March day in the midst of the Civil War. He received a law degree from the University of Virginia and practiced law in Chatham for six years before being elected to the U.S. House of Representatives, then governor of Virginia and later the U.S. Senate. Before World War II, he became secretary of the navy under Franklin D. Roosevelt.

In his capacity as navy secretary, he did much to influence a "big Navy." One cartoon in a Washington, D.C. newspaper quipped, "Mr. Swanson loves the Navy. He is never happier than when he is up to his ears in binnacles, turrets, quarterdecks, and deep sea gadgets of all kinds." The *Richmond News Leader* remarked that "more tonnage was added to the navy during his tenure than during the term of any other peace-time Secretary or any other Secretary."

When he died in July 1939, he received a state funeral in the U.S. Senate chamber. Attending were members of Congress, the Supreme Court and President Franklin Roosevelt and his cabinet. A horse-drawn caisson accompanied the funeral procession to Union Station, where a train took him for burial at Hollywood Cemetery in Richmond.

The Twentieth Century

His summer home, Eldon, on the outskirts of Chatham remains today as a monument to this great man. His vision of a strong navy served the country well when two years after his death Pearl Harbor was bombed and World War II began in earnest.

The *Pittsylvania County Tribune* reflected on the war years: "War was declared on the Axis powers and Pittsylvania found itself sending sons and brothers to places in the Pacific they had never heard of." By 1943, all able-bodied Pittsylvania County men eighteen to thirty-eight, married or single, were subject to be drafted. The war was in full swing.

During the war years, county residents actively supported the troops in the field with War Fund drives by the Red Cross, Victory Gardens, buying war bonds and using ration stamps to purchase necessities such as sugar, coffee, canned goods, meat, butter, gasoline, etc. The board of supervisors donated the cast-iron fence that surrounded the present courthouse to alleviate the shortage of metals.

Pittsylvanians fought in every campaign and in every theatre of the war. Many were members of the 116th Regiment of the 29th Division that landed at Omaha Beach on D-Day, June 6, 1944. Route 29, which stretches through Virginia, was named after that division due to the great sacrifices of life on D-Day at Normandy. Over 350 local servicemen were lost during the European and Pacific Campaigns, and many remain

Portrait of Staff Sergeant Archer Gammon, Pittsylvania County's recipient of the Congressional Medal of Honor awarded posthumously for bravery during the Battle of Bastogne in World War II. *Photo courtesy of Lawrence McFall.*

buried on foreign fields. The largest list of casualties, however, came from the Normandy Invasion.

Many medals were awarded to Pittsylvania County men for bravery. Henry Viccellio of Chatham commanded the Thirteenth Army Air Force Squadron in the Guadalcanal Campaign and was the operations officer for the ambush of the mastermind of the Japanese war effort, Admiral Yamamoto. The Japanese admiral was attacked as he flew over Bougainville in the Solomons in 1943. Viccellio received a promotion to lieutenant general after the war and held various air force command positions until he retired in 1968.

Clyde East, who also grew up in Pittsylvania County, was the most decorated Pittsylvanian in World War II as a member of the army air corps and added more medals in the Korean War. In 1955–56, he entered the Guinness Book of World Records for having the highest number of repeat combat awards up to that time.

The highest decoration of World War II went to Staff Sergeant Archer Gammon. He grew up on the family farm six miles north of Chatham and then moved with his parents to Danville to work in the textile mill. During the Battle of the Bulge at Bastogne in 1945, his platoon was pinned down by German fire. Singlehandedly, he saved his platoon from sure decimation and was posthumously awarded the Congressional Medal of Honor, the only Pittsylvania County serviceman to ever be so recognized.

World War II directly involved the county in at least one way besides its servicemen. German prisoners were kept in a prisoner of war camp at Sandy Level, some working on farms during tobacco season, others cutting timber for lumber and others working in a cannery. In Danville, German prisoners were housed in the former Danville Military Institute facility, a three-story Gothic Revival fortress. Five-star general George C. Marshall—President Roosevelt's chief of staff during World War II, author of the famous Marshall Plan for Europe's postwar recovery and later secretary of state under President Truman—taught history and military tactics at Danville Military Institute early in the twentieth century at the beginning of his army career.

The Korean War followed the end of World War II and resulted in nearly thirty-three local casualties. On November 27, 1950, Private First Class Elwood Reynolds, age nineteen, who had grown up on a Pittsylvania County tobacco farm, was among those fighting the Chinese army when it invaded the Chosin Reservoir in North Korea. As his division withdrew under the intense attack, he and several comrades were hurriedly buried in a common grave. Over fifty years after the war, Reynolds's grave was finally located by

search teams, and his remains were positively identified and returned home for burial on April 18, 2008. A black soldier, Private Joseph H. Tarpley of Callands, was also killed in Korea on June 14, 1952, in the Chorwan Valley and buried at Callands's Missionary Baptist Church.

The years after World War II and Korea sparked an era of development and prosperity. The standard of living in Pittsylvania County increased along with good prices for tobacco. Television made its appearance in the county in 1949, and E.L. Mayhew installed the first one at his Gretna home, with a sixty-foot-high tower to a get a snowy picture from Greensboro.

Television was a revolutionary change in the county, but it was the integration crisis of the 1950s that came to the forefront of public consciousness in Southside Virginia. When the U.S. Supreme Court ordered total desegregation of public schools, a groundswell of concern emerged in Pittsylvania and other counties. Caleb Brumfield, researching the period, found that from 1956 to 1958 nearly all the political advertisements and many editorials in Chatham's *Star-Tribune* focused on the subject. Articles on integration often eclipsed the number on farming. It was front-page news in almost every edition.

The issue was in effect the last gasp of the political machine named for U.S. senator Harry F. Byrd, a social, racial and financial conservative who had controlled Virginia politics from top to bottom for decades. County residents supported Byrd's massive resistance effort—vowing to close the schools in lieu of integrating them. The argument ran that desegregation would undermine "traditional Southern social barriers." More vocal opponents deemed it the most serious threat to the white race, one that would lead to its eventual destruction.

Brumfield notes that Pittsylvania County residents voted overwhelmingly on January 9, 1956, for a Virginia referendum designed to amend the state constitution to enforce segregation. The amendment would have allowed the state of Virginia to close the public schools if the federal government forced integration and redirect public money to private segregated schools where parents might choose to send their children.

After this freedom-of-choice plan was ruled unconstitutional, the Pittsylvania County School Board proposed "voluntary segregation," where black students would opt for more modern buildings with running water and central heating in place of integrating the schools. This not-so-subtle proposal did not work either, and in time massive resistance to integration faded. By 1966, Richard N. Johnson ran for Chatham Town Council, the first African American to run for a local political office. He lost the election, but the vote count showed that he received significant white support.

Pittsylvania County, Virginia

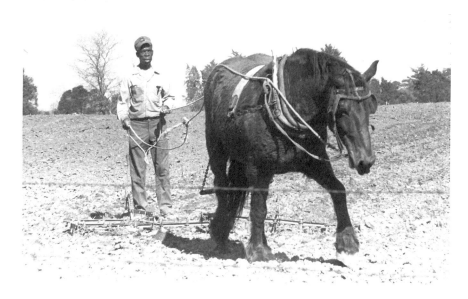

Earlier in the twentieth century, this black farmer in Pittsylvania County used a drag after plowing to smooth out clods of dirt as he prepared the ground for the next crop. *Photo courtesy of* Star Tribune.

In the summer of 1963, Danville police and city workers attacked black marchers at the city hall, spraying them with fire hoses and hitting them with clubs. Martin Luther King Jr. later visited Danville and proclaimed that it was the worst police brutality he had seen in the South. However, despite this initial resistance in the city and the county, in time integration issues in both areas faded from the political scene. Today, fully integrated county and city schools serve both black and white students equally.

Besides integration, the war in Vietnam also affected the county. Captain William Reynolds Martin of Callands, an air force pilot, lost his life in combat in Laos on November 18, 1864. He was awarded the Purple Heart and the Air Force Cross for his sacrifice. Altogether forty-five local men lost their lives in that protracted war—most from Danville and others from Gretna, Callands, Keeling and Chatham. Their names are inscribed on the Vietnam Memorial in Washington, D.C., and the Veteran's Memorial Park in Danville's Dan Daniel Park.

While the Vietnam War affected the county, so did agricultural changes. Farming was still a way of life in the last half of the twentieth century,

The Twentieth Century

Tobacco piles lined up along the floor of a warehouse where the tobacco is auctioned off to buyers. *Photo courtesy of* Star-Tribune.

The Auction, by Nancy Compton, features tobacco buyers examining tobacco leaves as they follow the auctioneer's chant during a sale.

A parade along Main Street in Chatham featuring the Hargrave Military Band. An election banner for John Battle, Virginia's governor from 1950 to 1954, hangs in the background. *Photo courtesy of* Star-Tribune.

yet those farms were not the farms of yesteryear. An article in the county newspaper dramatized the farmer of the 1960s as one who lived in a freshly painted five-room house with electricity and running water, drove a late-model Ford or Chevrolet, had a new tractor and modern farm machinery to take the place of the two old mules and cured his tobacco in a barn equipped with modern automatic oil curers. He owned combines, hay balers, corn pickers, hammermills and a riding two-row tobacco planter. In other words, as the *Tribune* quipped, "The Pittsylvania grower was no longer a one mule clod knocker."

Also in the sixties, the town of Hurt was incorporated. John L. Hunt inherited Clement Hill, where gunpowder was made during the Revolution and the Civil War. Hunt laid off streets fifty feet wide and marked off lots, which he sold for $200 each. By 1964, the town of Hurt had 1,250 citizens. When Hunt died, he left Clement Hill and a sizeable sum to the town.

The sixties also witnessed the Smith Mountain Dam construction in the gap of the Smith Mountains, which formed a lake forty miles wide covering 20,000 acres with five hundred miles of shoreline. Leesville Dam seventeen miles downstream created an additional lake with one hundred miles of shoreline covering 3,400 acres. This hydroelectric

The Twentieth Century

project provided Pittsylvania and surrounding counties with recreational opportunities and also prompted the development of local communities around the lake area.

In 1969, a survey revealed that tobacco production accounted for 85 percent of county farm income. In total tobacco acreage, Pittsylvania County tobacco ranked first in Virginia and eighth in the United States. By 1976, Pittsylvania County's agricultural production included beef and dairy cattle, hogs, wheat, corn and other grain crops and nearly 52 million pounds of tobacco. Farming was still a serious endeavor, even though other industry was coming to the forefront.

In 1969, Pittsylvania County industrial development was well on its way and brought in over a million dollars of tax revenue from tobacco, textiles and major national companies such as Goodyear Tire and Rubber Company and Corning Glass. By the late decades of the twentieth century, the mainstays of the region's economy, tobacco and textiles were on a downward trend. The textiles as well as tobacco struggled against cheaper foreign imports. Tobacco's future also became uncertain due to the government's regulatory actions and lawsuits against tobacco companies, as well as the public's lessening demand for tobacco products.

The governments of both Danville and Pittsylvania County introduced a vision for industrial parks to bring in new industry. According to *Virginia Business* magazine, "Between 1985–1996, 29 businesses announced they were moving to Pittsylvania County." During the same time period, 33 existing businesses expanded. Altogether, these investments totaled over $300 million.

In 1988, after a protracted battle, the City of Danville annexed twenty-six square miles of the county, absorbing almost ten thousand residents and six major industries. Despite this conflict, economic growth continued for both the county and the city. By 1997, Danville and Pittsylvania County were the only Virginia communities listed among the "310 top manufacturing metropolitan statistical areas in the country."

Thus ended an extraordinary century, one that began with railroads, horses and wagons and ended with modes of transportation that turn-of-the-century folks in Pittsylvania County could not have envisioned—cars and trucks of all shapes and sizes, and airplanes crisscrossing the skies. Satellite TV and cellphones, microwaves and air conditioning, computers and the Internet—all unheard of at the beginning of the twentieth century, but most became commonplace in Pittsylvania County by the year 2000.

CHAPTER 14

Millennium Makeover

Over the past three hundred years, Pittsylvania County has experienced both trying times and triumph. Frontier settlers seeking to carve out a living in the wilderness repelled Indian incursions, suffered a preponderance of diseases and struggled against the forces of nature. They sent their sons, husbands and brothers off to the American Revolution, their grandsons to the Civil War and their descendants to the wars of the twentieth century.

The county prospered first with tobacco and then with textiles, grappled with Reconstruction and later the Great Depression and adapted to unparalleled changes in the twentieth century. Through it all, tobacco and textiles saw their ups and downs but continued to be the mainstays of the county and Danville's existence. Social, political, economic, religious and other monumental cultural changes notwithstanding, the county has survived and prospered again and again.

In this third millennium, though other industries have been successfully attracted to the area, the county has had to face a terrible downturn in tobacco and the devastation of the textile industry along the banks of the Dan. Coupled with dwindling public consumption of tobacco products and competition from cheaper foreign imports, tobacco production slid downhill in the late twentieth century. Farm income dropped. Then, in 2004, the government did away with its price support system and allowed the farmers to grow as much as they wanted and compete in a free market against foreign competitors.

Millennium Makeover

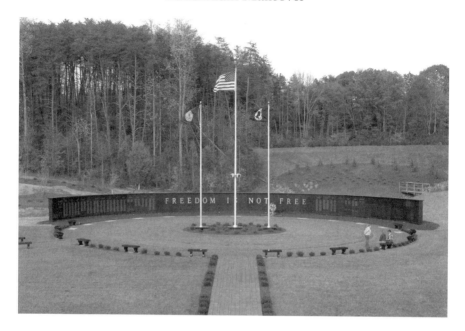

The Veteran's Memorial of Danville and Pittsylvania County, dedicated in 2008 in Dan Daniel Park, posts the engraved names of those from the area who have died in all our nation's wars. *Photo by Mark Aron.*

Even so, the production of that golden leaf has not been as it was in the golden years. In 1976, tobacco farms in Pittsylvania County produced 52 million pounds, but by 1996, according to the National Agricultural Statistics Service of the USDA, county farms produced only 22 million pounds and in 2006, 13.5 million. Over time, the number of farms in the county has decreased as well, from 4,690 farms in 1950 to 1,304 farms in 2002.

The changes in the government's tobacco program did away with the loose-leaf tobacco sales on the warehouse floor and auctioneer's rapid-fire chant, leaving only enormous empty buildings in Danville that echo with memories of the past. Dimon, one of the world's largest leaf dealers in processing and reselling tobacco, closed its Danville operation in 2004. About all that remains of tobacco's former dominion are P. Lorillard's voluminous storage facilities off Route 58 East. The bulk barns with their modern curing methods have replaced the old tobacco barns that still dot the dirt roads and byways of the county, a reminder of yesteryear and the sweet aroma that emanated from them during tobacco season.

Not only has tobacco become endangered in the county, but also out of the twentieth century came a Dan River Mills struggling with foreign

Pittsylvania County, Virginia

A remnant of the past, this old tobacco barn in the Elkhorn community of Pittsylvania County once offered passersby the sweet smell of curing tobacco.

competition. The company declared bankruptcy in 2004, and two years later Dan River sold to an India-based company, Gajarat Heavy Chemicals Ltd., which moved the operation overseas.

Today, only empty reminders of buildings exist that once hummed with machinery that made Dan River, with its home fashion products and apparel fabrics, an international name. Even these buildings are now being removed, their gigantic smokestacks and their mammoth frames of brick and wood that once swept across the skyline recycled for other uses.

During the economic downturn in the Metropolitan Statistical Area comprising Danville and Pittsylvania County, from 2001 to 2005 there were 8,834 full-time jobs lost. But the demise of tobacco and textiles served as a catalyst to fuel growth. Alarmed at the losses, the Danville Pittsylvania County Chamber of Commerce was organized, combining the efforts of both city and county realizing their common interests. Coupled with grants from the Virginia Tobacco Commission, which received funds from the nationwide settlement of litigations against tobacco companies, Danville and Pittsylvania County have hosted new industry, educational initiatives and research facilities.

From 1999 to 2008, as many as six thousand jobs were created in the area, some in manufacturing but most in the service industry. Existing industry

expanded. New industry, some from countries around the globe including Sweden, Japan, Poland, India and Great Britain, found a home in Danville and Pittsylvania County.

Recognizing that agriculture is still the number one industry in Pittsylvania County, the Tobacco Commission has contributed funds for an agricultural complex along Route 29 in Pittsylvania County, which will serve as a "regional hub for high-quality agricultural events and products."

Commission grants also helped fund the Cane Creek Centre, an industrial park in Pittsylvania County, as well as the Institute for Advanced Learning and Research (IALR) in Danville, both a joint venture between city and county. Tobacco Commission grants, as well as finances from other sources, have made the IALR a state-of-the-art research and development facility, with a major advanced education component designed to address the workforce development needs of local industry.

The IALR's mission is to attract and develop technology critical to Southside Virginia's economic prosperity. Included under its umbrella are horticulture and forestry research, polymer processing, robotics and performance engineering. In 2008, the Tobacco Commission awarded $8 million to IALR for a Sustainable Energy Technology Center to research the genetic engineering of nonfood plants such as switchgrass into biofuels and

The Institute for Advanced Learning and Research hosts research centers focused on agricultural, engineering and chemical technology geared toward improving the local and regional economy.

other bio-products. At the Cyber Park nearby, another joint venture between Danville and Pittsylvania County, new companies will focus on hybrid fuel technologies for the automobile industry and recycling biowaste material into viable agricultural products.

In 2005, the National Aeronautics and Space Administration (NASA) chose the Danville Airport to test technologies related to its Small Aircraft Transportation System that is geared to improving aviation and making air travel more accessible. Other industry in the area includes Luna Innovations, a research and development company embracing practical application of nanotechnology. Pittsylvania County and Danville have also joined together in developing eDan, an initiative to help bring high-speed Internet accessibility to citizens and businesses throughout Southside Virginia.

While it is true that tobacco and textiles are no longer the viable industries they once were to the county and city, the new "t" of technology has become the byword for the future. Farmers, former millworkers and all the area's citizens will benefit from this technology-based research, which will not only produce innovative crops to provide for the needs of the next generation, but will also attract new businesses to employ people of the region.

Even below the ground is a mineral deposit that William Byrd and early explorers could not have imagined. Pittsylvania County has the largest undeveloped uranium ore deposit in the United States and the seventh in the world, worth an estimated $10 billion. While its mining is controversial, safe technologies are necessary to ward off any environmental damages. The deposit was discovered on land belonging to Walter Coles of Cole's Hill, the plantation home built by his ancestor of the same name, a son of early settler Colonel Isaac Coles.

Even though uranium mining in the county is divisive, mining continues to be a vital part of Pittsylvania County's economy in the new millennium. Vulcan's aggregate materials quarry at White Oak Mountain and other nearby areas produces crushed rock for construction, asphalt highways and decorative purposes.

The land then, despite all the contributions of technology, is still Pittsylvania County's best asset. According to the *Star-Tribune*:

> *In 2004, Pittsylvania ranked first in Virginia for flue-cured tobacco sales and fifth in corn for silage and hay production. Cattle, beef cows, and milk cows placed Pittsylvania in the top six producers in the Commonwealth. Equine, swine, sheep, goats, horticulture and viticulture groups are also growing industries. This means that agriculture is a driving economic force in the county.*

Millennium Makeover

Above left: Tony Womack, a Pittsylvania County native and graduate of Gretna High School, powered the Arizona Diamondbacks' win in the 2001 baseball World Series.

Above right: Retired tobacco farmer and postal carrier Norman Amos, recognized by the Smithsonian Institution as the greatest living master of the Appalachian tradition of snake cane carving, at his workshop in Callands.

As Pittsylvania County's economy recovers once again from difficult times, its people are further inspired by the successes of its school system. Pittsylvania County schools are fully accredited and equipped with more advanced technology resources than other schools in the region. In 2002, the school system received the coveted Governor's Gold Technology Award for its innovative use of technology.

Many talented artists have come from the county and also serve as an inspiration: country music star Rickey Van Shelton; bluegrass music legend Tony Rice; Janis Martin, the 1950s Rockabilly Queen; professional baseball's Tony Womack; and snake cane carver Norman Amos. Other talented artists hail from the county as well, such as sisters Barbara and Karen Hall, who both graduated from Chatham High School. Both have achieved remarkable success in television and writing, accumulating numerous awards, including Emmy and Golden Globe nominations.

In 2006, Claudia Emerson, who grew up in Pittsylvania County and also attended Chatham Hall, received the Pulitzer Prize for Poetry for her work

Pittsylvania County, Virginia

Claudia Emerson, Pittsylvania County native and recipient of the Pulitzer Prize for Poetry 2006, at her family home in Chatham.

Late Wife: Poems. These poems and her other published collections are filled with reflections of her life in Pittsylvania County. Today, she is Virginia's poet laureate and an associate professor of English at Mary Washington College in Fredericksburg, Virginia.

Her thoughts during an interview at her parents' home in Chatham provide a fitting conclusion to this brief history:

> *I don't think people always give Pittsylvania County enough credit for what I call its subtle beauty. In places it's not even that subtle. There are parts of the county that are quite mountainous. You've got river country, too. It's just gorgeous. It's just beautiful.*
>
> *We have a lovely home in old town Fredericksburg, but it's on a busy corner. There's just something going on all the time—a lot of traffic. But at night here it's like being out in the country—you don't hear anything. It's changed of course since I grew up in Chatham, but not as much as other places. There are a whole lot of possibilities here.*

One of her fondest stories, told to her by her dad, Claude, was of him in the early twentieth century as a young boy riding over White Oak Mountain in a wagon of tobacco bales that his father was taking to market in Danville. As they traveled in the darkness, Claudia's father was awakened by her

grandfather, who pointed out to him two points of light in the distance. "Do you know what they are?" he asked young Claude. "Two moons," responded the young boy. Actually, they were the headlights of a car. Claudia Emerson reflected on that event, remembering the rarity of automobiles at that time: "It was easier to imagine two moons than two car headlights."

As the history of Pittsylvania County continues to unfold with car-filled highways and the accumulations of a progressive society, let preserving the beauty and majesty of this place always be a priority. May there always be room to see the darkness, hear the silence and feel the power of nature's symphony in our hearts.

Bibliography

BOOKS

Alvord, Clarence W., and Lee Bidgood. *First Explorations of the Trans-Allegheny Region by the Virginians, 1650–1674.* Cleveland, OH: Arthur H. Clark Co., 1912.

Beverley, Archie Swanson. *Growing Years: The Development of the Whitmell Farm-Life School.* NY: Vantage Press, 1955.

Beverley, Robert. *The History and Present State of Virginia.* London: R. Parker, 1705.

Byrd, William. *The Westover Manuscripts.* Petersburg, VA: Edmund and Julia C. Ruffin, 1841.

Calendar of Virginia State Papers (1652–1793). Preserved in State Library at Richmond. Edited by Dr. William P. Palmer. 6 vols. Richmond: Commonwealth of Virginia, 1875–86.

Clement, Maud Carter. *The History of Pittsylvania County.* Lynchburg, VA: J.P. Bell, 1929.

———. *The Writings of Maud Carter Clement.* Chatham, VA: Pittsylvania County Historical Society, 1982.

Cross, Malcolm A. *Dan River Runs Deep.* Middleton, NY: Whitlock Press, 1982.

Egloff, Keith, and Deborah Woodward. *First People: The First People of Virginia.* Second edition. Charlottesville: University of Virginia Press, 2006.

Fitzgerald, Madalene Vaden. *Pittsylvania: Homes and People of the Past.* Lynchburg, VA: Homeplace Books and H.E. Howard, 1974.

Freeman, Douglas Southall. *George Washinngton: A Biography.* Volume III. New York: Charles Scribner's Sons, 1951.

Garrett, Mary Brumsfield. *Bright Leaf: An Account of a Virginia Farm.* Blacksburg, VA: published by author, 1971.

Gregory, G. Howard. *53rd Virginia Infantry and 5th Battalion Virginia Infantry.* Lynchburg, VA: H.E. Howard, 1999.

———. *History of the "Wreck of Old 97."* Danville, VA: published by author, 1981.

———. *38th Virginia Infantry.* Lynchburg, VA: H.E. Howard, 1988.

Griffith, Alva H. *Pittsylvania County, Virginia Register of Free Negroes and Related Documentation.* Westminster, MD: Heritage Books, 2001.

Hagan, Jane Gray. *The Story of Danville.* New York: Stratford House, 1950.

Bibliography

Hairston, L. Beatrice W. *A Brief History of Danville 1728–1954*. Richmond, VA: Dietz Press, 1958.

Hall, Charles C., comp. *A Scrapbook on Claude Augustus Swanson*. 1992. Available at Pittsylvania County Public Library.

Heineman, Ronald L., John G. Kolp, Anthony S. Parent Jr. and William G. Slade. *Depression and New Deal in Virginia*. Charlottesville: University of Virginia Press, 1983.

———. *Old Dominion New Commonwealth: A History of Virginia 1607–2007*. Charlottesville: University of Virginia Press, 2007.

Hening, William Waller. *The Statutes at Large, Being a Collection of All the Laws of Virginia, 1619–1792*. Volumes 8, 10 and 12. Reprint. Charlottesville: University of Virginia Press, 1969.

Hurt, Frances Hallam. *Eighteenth Century Landmarks of Pittsylvania County, Virginia*. Lynchburg, VA: Blue Ridge Lithographic Corporation, 1966. Republished by Pittsylvania County Historical Society, 1986.

———. *An Intimate History of the American Revolution in Pittsylvania County, Virginia*. Danville, VA: Womack, 1976.

Jones, Langhorne, Jr. *The History and Development of Competition*. Chatham, VA: Pittsylvania County Historical Society, 2008.

Jones, Mary Ann. *A Fading Heritage: History As Seen Through Native Eyes*. Published by author, 1984.

Leek, Charles F. *The History of Pittsylvania Baptist Association 1788–1763*. Danville, VA: Pittsylvania Baptist Association, 1963.

Link, William A. *The Paradox of Southern Progressivism 1880–1930*. Chapel Hill: University of North Carolina Press, 1992.

McAllister, J.T. *Virginia Militia in the Revolutionary War*. Hot Springs, VA: McAllister Publishing Co., 1913.

McDonald, James J. *Life in Old Virginia*. J.A.C. Chandler, editor. Norfolk, VA: The Old Virginia Publishing Co., 1907.

McFall, F. Lawrence, Jr. *Danville in the Civil War*. The Virginia Regimental Histories Series. Lynchburg, VA: H.E. Howard, 2001.

Melton, Herman. *Pittsylvania County's Historic Courthouse: The Story Behind Ex Parte Virginia and the Making of a National Landmark*. Chatham, VA: Pittsylvania County Historical Society, 1999.

———. *Pittsylvania's Eighteenth-Century Grist Mills*. Lynchburg, VA: H.E. Howard, 1989. Reprint by Pittsylvania County Historical Society, 2004.

———. *Pittsylvania's Nineteenth Century Grist Mills*. Charlotte, NC: Delmar Printing Co., 1991.

———. *Southside Virginia: Echoing Through History*. Charleston, SC: The History Press, 2006.

———. *"Thirty-Nine Lashes-Well-Laid On" 1750–1950*. Fredericksburg, VA: Sheridan Books, 2002.

———. *Visitor's Guide to Early Industry in Pittsylvania County*. Chatham, VA: Pittsylvania County Historical Society, 1998.

Motley, Charles B. *Yes, There is a Dry Fork, Virginia*. Bassett, VA: Bassett Printing Co., 1977.

Pollock, Edward. *A Sketchbook of Danville, Virginia: Its Manufacturers and Commerce*. Petersburg, VA: 1885.

Popek, Diane. *Tracks Along the Staunton: A History of Leesville, Lynch Station, Hurt and Altavista*. Altavista, VA: Altavista Printing Company, 1984.

Robertson, James I. *18th Virginia Infantry*. Lynchburg, VA: H.E. Howard, 1984.

Ruben, Louis D., Jr. *Virginia: A Bicentennial History*. New York: W.W. Norton, 1977.

Bibliography

Siegel, Frederick F. *The Roots of Southern Distinctiveness: Tobacco and Society in Danville, Virginia 1780–1865*. Chapel Hill: University of North Carolina Press, 1987.

Smith, Robert Sidney. *A History of Dan River Mills 1882–1950*. Durham, NC: Duke University Press, 1960.

Sobel, Mechal. *The World They Made Together: Black and White Values in Eighteenth Century Virginia*. Princeton, NJ: Princeton University Press, 1987.

Sublett, Charles W. *57th Virginia Infantry*. Lynchburg, VA: H.E. Howard, 1985.

Talbot, Sir William, trans. *The Discoveries of John Lederer*. London: Printed by J.C. for Samuel Heyrick, 1672.

Tyler, Estelle Ironmonger. *The Junction: Elba-Gretna, Virginia*. Gretna, VA: published by author, circa 1990.

Wiencek, Henry. *The Hairstons: An American Family in Black and White*. New York: St. Martin's Griffin, 1999.

WPA Writer's Project. *Virginia: A Guide to the Old Dominion*. Richmond: Virginia State Library and Archives, reprint 1992.

MAGAZINES

Beard, James S. "Volcanoes in Virginia." *Virginia Explorer* (Spring 1994): 2–9.

Fraser, Nicholas C. "Cascade: A Triassic Treasure Trove." *Virginia Explorer* (Winter/Spring 1993): 15–18.

NEWSPAPERS

McLean, Mac. "Solite Quarry a treasure trove of prehistoric insect fossils." *Danville Register and Bee*, November 25, 2004.

O'Conner, Adrian. "How it all began for city on the Dan." *Danville Register and Bee*, May 15, 1993.

Star-Tribune. February–November 1943; June 15, 1967; Bicentennial Issue, January–November 1969.

WEBSITES

Altman, Forrest. "Adventures in the Dan River Basin." Dan River Basin Association. http://www.danriver.org/PDRs/Adventures_in_the_Dan_River_Basin.pdf.

Austin, Gayle Beverley. "History of Pittsylvania County. VaGen Web Pittsylvania County, Virginia Genealogy Project." http://www.rootsweb.ancestry.com/~vapittsy/history.htm.

Bland, Laura. "Danville/Pittsylvania County: Make Way for Southside's Industrial Revolution." Virginia Business Magazine Online. http://www.virginiabusiness.com/edit/magazine/yr1997/june97/june97/danville.html.

Grymes, Charles A. "From Paleo-Indian to Woodland Cultures: Virginia's Early Native Americans." http://www.virginiaplaces.org/nativeamerican/6_archai.html.

Marks, Jennifer. "Dan River Liquidating." *Home Textiles Today*. April 21, 2008. http://www.hometextilestoday.com.

Mitchell, Henry H. "Guide to Pittsylvania County." www.chathamguide.com.

Virginia Historical Society. "The Story of Virginia: Becoming a Homeplace." http://www.vahistorical.org/sva2003/homeplace.htm.

U.S. Census Bureau. "State and County Quick Facts. Pittsylvania County." http://quickfacts.census.gov/qfd/states/51/51143.html.

Bibliography

JOURNALS, PAPERS AND DIARIES

Anderson, James. "James Anderson's Book." Excerpt from diary written near Richmond, Virginia, 1864.

Barber, Michael B., and David A. Hubbard Jr. "Overview of the Human Use of Caves in Virginia: A 10,500 Year History." *Journal of Cave and Karst Studies* 59 (3): 132–36.

Carter, Lyman. "The Veracity of John Lederer." *William and Mary Quarterly* 2.19, no. 4 (October 1939): 435–45.

Fuller, Mabel C., Viola W. Shorter and Landon E. Fuller. "Pittsylvania County Geographical Supplement." Spring Quarter. Charlottesville: University of Virginia, 1925.

Gosnell, William, and Howard A. MacCord Sr. "The Keatts Site: Pittsylvania County, Virginia." Paper submitted to *Archaeological Society of Virginia Quarterly Bulletin*, 1998.

Mitchell, Sarah, ed. *The Pittsylvania Packet*. Spring. Chatham, VA: Pittsylvania County Historical Society, 2008.

Williams, Mike, ed. *Piedmont Lineages*. Bulletin of Virginia/North Carolina Piedmont Genealogical Society. Danville, VA: various issues cited from 1990–2007.

MASTER'S THESES AND GRADUATE PAPERS

Bridges, Karl. "The In-Between South: Households, Slaveholding, and Production in Southern Pittsylvania County, Virginia, 1850." Master's thesis, Miami University, 1988.

Brumfield, Caleb. "Idle Threats: Massive Resistance in Pittsylvania County: 1954–1959." Seminar paper History 703, University of North Carolina, December 2006.

MAPS

Ricketts, Danny. *Part of Pittsylvania County in 1850*. Danville, VA: Danny Ricketts, 1994.

Rietsch, Pam. *Pittsylvania County 1895 Map*. Originally published by Rand McNally in *The New 11 x 14 Atlas of the World*. Available at www.USGenNet.org

Whitt, Terry. *Pittsylvania County Map 2008*. Chatham, VA: Pittsylvania County GIS Department, 2008.